Pattern Sourcebook:
Nature
250 Patterns for Projects and Designs

Shigeki Nakamura

BEVERLY MASSACHUSETTS

ROCKPORT PUBLISHERS

First published in the United States of America by
Rockport Publishers, a member of
Quayside Publishing Group
100 Cummings Center
Suite 406-L
Beverly, Massachusetts 01915-6101
Telephone: (978) 282-9590
Fax: (978) 283-2742
www.rockpub.com

ISBN-13: 978-1-59253-558-3
ISBN-10: 1-59253-558-5

10 9 8 7 6 5 4 3 2

Translation: Patricia Daly Oe (R.I.C. Publications)

Printed in Singapore

Preface

Among the various groups of traditional Japanese patterns, those featuring "waves" and "clouds" fall under the category of patterns depicting natural phenomena.

It may be because Japan is surrounded by the sea that waves, in particular, have been used often in traditional patterns and this is still true of the present time. On the other hand, clouds help to draw a design together and are important motifs in conveying the scale of a design. The difficulty in understanding how to represent constantly shifting natural phenomena in patterns lies in the inadvertent tendency towards realistic portrayal. However, there is a lot to learn from the sense that our predecessors had to create shapes from natural phenomena and to establish the forms for beautiful patterns.

The model shapes (fixed forms) of "*Seigai* waves" and "*Kanze* water," "auspicious clouds" (*Zuiun*), "shaped clouds," and "mist" were created from a spiritual state, inspired by nature. As long as the basic conventions governing fixed forms are adhered to they can be used and developed in any number of ways to create impressive new patterns without appearing to greatly damage the basic form.

Compared to previously published patterns, the material in this book is not so realistic and is arranged in an easy-to-use way as a reference for design development or patterns. Also, chapters 3 and 4 show how to develop continuous patterns.

My hope is that the readers will use this material to create their own original designs and help to elevate Japanese traditional patterns to an even higher level.

Shigeki Nakamura (Cobble Collaboration)

Contents

Chapter 3 Continuous Wave Patterns 77

Chapter 4 Continuous Cloud Patterns 113

How to use this book

[Explanatory Note]

● Materials in the designs have been extracted from the existing traditional cloud and wave patterns in order to focus on the main points specified in the text of this book.

● Our main aim is to present the patterns in a way that the structure of the design can be used for development. Consequently, we have modified many of the cloud and wave patterns and special features of the patterns to present them with our own original layout and coloring. Although the designs are based on the traditional designs, they are not the designs shown in their original form.

The files on the CD-ROM are, in principle, complete unit samples, but the images used as materials in the book have been trimmed to fit the layout and the colors have been partially modified in some cases. Also, some of the complete data has been re-sized to fit the content of the CD-ROM.

Page Layout

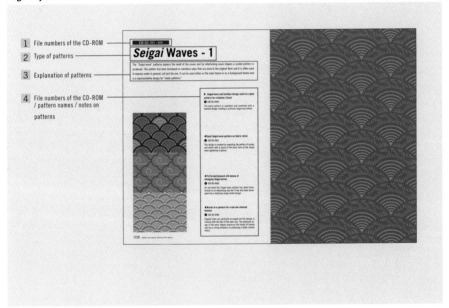

1 File numbers of the CD-ROM

2 Type of patterns

3 Explanation of patterns

4 File numbers of the CD-ROM / pattern names / notes on patterns

Chapter 1
Wave Patterns
CD 01:001-070

Seigai Waves - 1

The "*Seigai* wave" patterns express the swell of the ocean and by interlocking wave shapes a scaled pattern is produced. This pattern has been developed in countless ways that are close to the original form and it is often used to express water in general, not just the sea. It can be used either as the main theme or as a background theme and is a representative design for "water patterns."

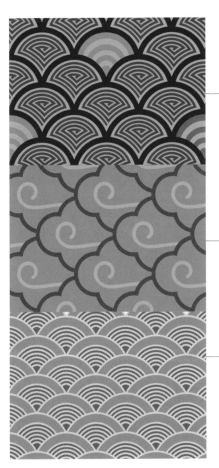

▶ *Seigai* wave and bamboo design used in a dyed pattern for a kimono (*Suou*)

◉ CD 01-004

The wave pattern is repeated and combined with a bamboo design, creating a profound *Seigai* wave effect.

◀ Dyed *Seigai* wave pattern on fabric (*Gire*)

◉ CD 01-001

This design is created by repeating the pattern of scales and whirls with a touch of the basic form of the *Seigai* wave appearing in places.

◀ Patterned damask silk weave of changing *Seigai* waves

◉ CD 01-002

On one hand the *Seigai* wave pattern has been transformed in an interesting way but it has also been developed into a matching single vortex design.

◀ Waves in a pattern for a narrow-sleeved kimono

◉ CD 01-003

Elegant lines are perfectly arranged yet the design is infused with the feel of the open sea. The extensive usage of the wave shapes expresses the height of beauty and has a strong influence on producing a rather somber effect.

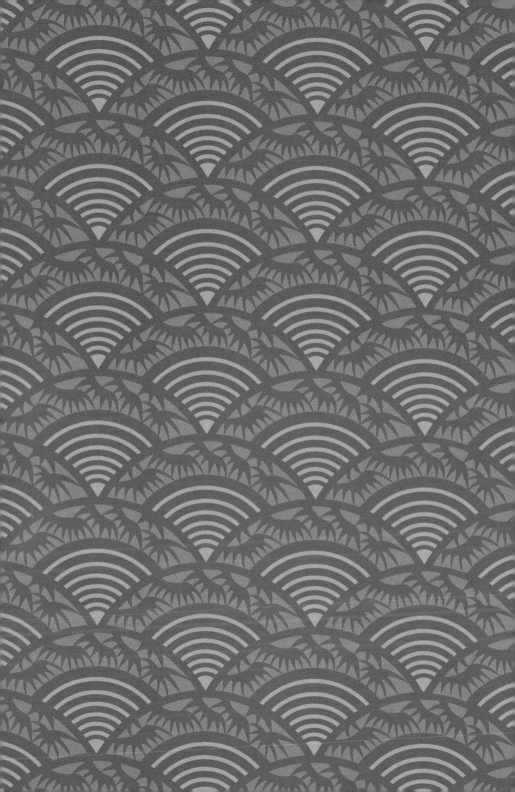

Seigai Waves - 2

It is often the case that the conventions of traditional patterns change along with the era. For example, the "snow pattern" that is rarely used now; when we see this pattern that symbolizes a natural phenomenon used around the edges of the Taiko drums it is hard for us to associate it with snow. However, if we become acquainted with seeing the backgrounds to when this pattern is used, we could be able to perceive the atmosphere of a snow scene according to convention. On the other hand, "The *Seigai* wave" patterns have attained a universal appeal that has surpassed the era.

▶ *Seigai* waves on a kimono embroidered and impressed with gold foil

◉ CD 01-008

A dignified arrangement of *Seigai* waves. The shape of the waves creates an undulating effect and is also similar to the famous "*Oshidori* (Mandarin duck) Cherry Blossom" impressed gold and silver foil pattern.

◀ Rough waves on gaily colored paper

◉ CD 01-005

The design follows the fixed form of the *Seigai* wave pattern. Whilst the lines do not look contrived, it conveys a sense of uniformity. It is an effective expression of rough waves.

◀ *Kyo-Yuzen* background of *Seigai* waves

◉ CD 01-006

The technique of conveying uniformity and creating a unique rhythm is often seen in traditional designs. The color tones are also graceful.

◀ A dyed pattern of *Seigai* waves

◉ CD 01-007

Seigai waves inside *Seigai* waves. As the pattern is longer than it is wide it does not have a cramped feel to it.

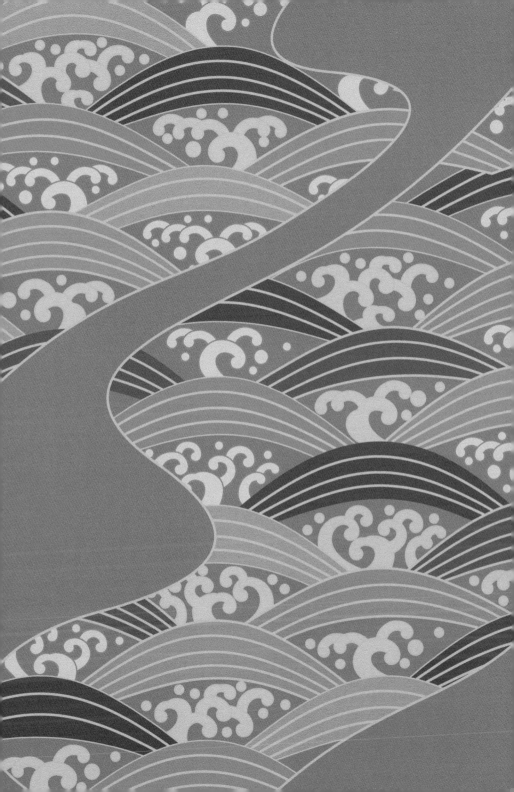

Kanze Water (*Kanzemizu*)

As this pattern was adopted by Kanze Tayu for Noh performances it has become the formal crest for the Kanze family. The composition of the vortex itself lends the appearance of quietly and endlessly flowing water and creates a graceful and magnificent water design. By making just a slight change to the structure of this water-themed design, it has the ability to convey a wide range of expressions, from silence to intimate emotions.

▶ *Kanze* water design on a Noh costume

⬤ CD 01-012

This is the representative *Kanze* water pattern. Through its splendid and noble atmosphere it appears to convey the content of Noh plays.

◀ Kyoto-style *fusuma* paper with *Kanze* water pattern

⬤ CD 01-009

This is a stylized *Kanze* water design that gives full expression to its sense of calm and quiet.

◀ Waves on a dance costume

⬤ CD 01-010

This design is not stylized but in order to express "feelings of distraction" it has been broken up in a stylized way.

◀ *Kanze* water embroidery and impressed gold foil

⬤ CD 01-011

Although the color tones are simple, the stately qualities express the magnificence of flowing water.

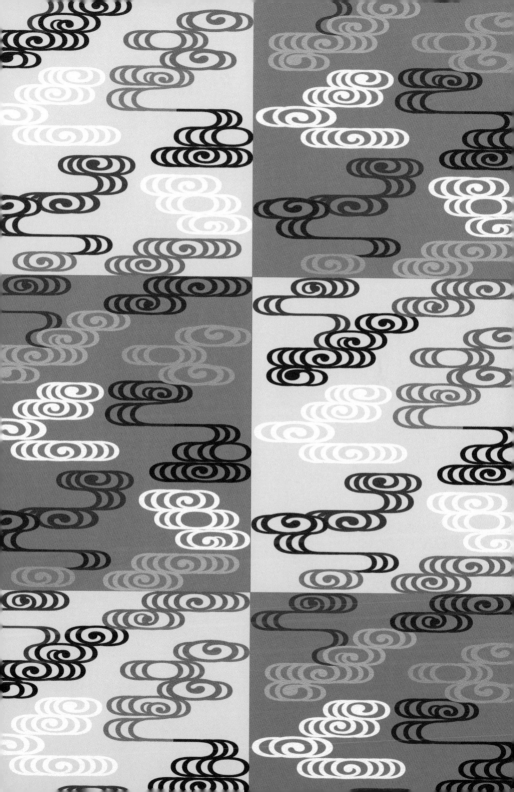

Rough Waves (*Hatou*) - 1

Among all of the representations of waves the most variations on the theme are shown in the "rough wave patterns". The appearance of the high waves breaking inspires the vision of many kinds of scenes in the minds of the people facing the picture. It is undeniable when viewing a traditional "*Hatou*" that it captures the momentary movement of the waves in its form and manages to express the aesthetic quality of waves that have an inexpressible beauty to them. The fact that the basic structure forms the main design that plays the leading role in "the rough wave patterns," makes them freshly invigorating design models.

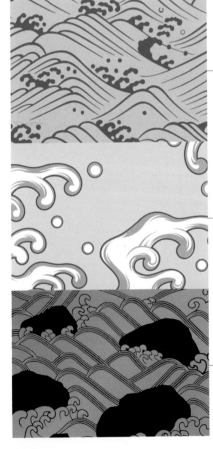

▶ **Waves on *Kohrin* gold-lacquered ink-stone case**

● CD 01-016

This design does not have an ancient feel to it but rather the more you look at it the more you perceive the sense of endless beauty conveyed by the three line waves and fine rhythmical style.

◀ **Waves on Kyoto-style *fusuma* paper**

● CD 01-013

The dancing waves do not appear contrived, do not encumber the picture and are soft on the eyes. This is a design that is pleasing to look at with a healing effect.

◀ **Big waves on a *Nabeshima* dish**

● CD 01-014

The simplified powerful waves in this design render the decoration appropriate for such a dish.

◀ **Waves on *Kohrin* gold-lacquered ink-stone case**

● CD 01-015

The shape of the waves is beautiful in this design or rather the image conveyed by the development of the design.

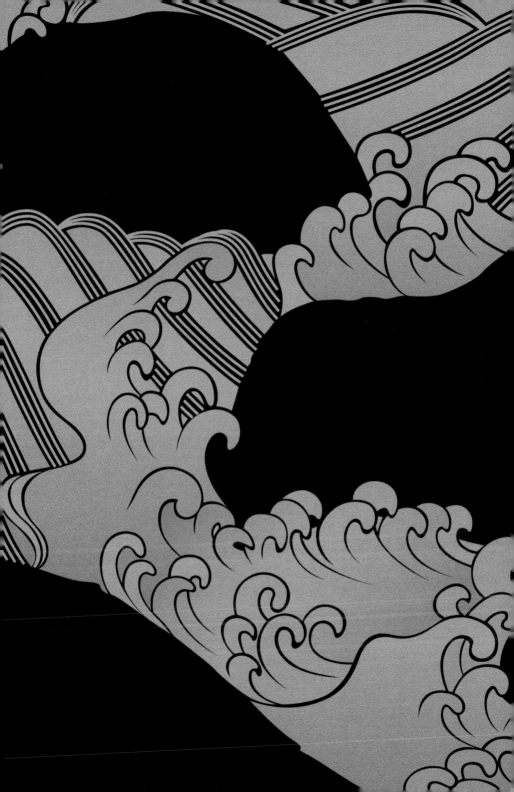

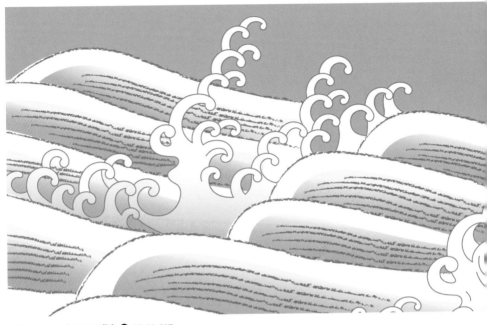

▲ **Waves on an *Imaemon* dish** ● CD 01-017
The contrast of the strong swell of the waves and the white waves dancing on top is impressive.

▼ **Moon over waves on a stone dish** ● CD 01-018
This is an attractive design that catches the eye with its quiet expression together with the fast movement of the powerful brush strokes.

▲ *Oribe Hatou* design on a square plate ◉ CD 01-019
The intuitive appearance of this depiction of rough waves has been skillfully developed and it directly conveys a powerful feeling.

▲ *Hatou* design on a campaign jacket (short jacket worn over armor) ◉ CD 01-020
The way in which the rough wave is lifted up to the center of the rising sun conveys the atmosphere of the recitation of an epic poem.

▲ **Celebration Flag with *Hatou* design - 1** ⬤ CD 01-021
The bold composition and realistic feel give the design a sense of restraint.

▼ **Celebration Flag with *Hatou* design - 2** ⬤ CD 01-022
Many of the fishermen's flags to celebrate a rich haul are realistic but together with design number 021 (above) this is a stylish depiction of the waves.

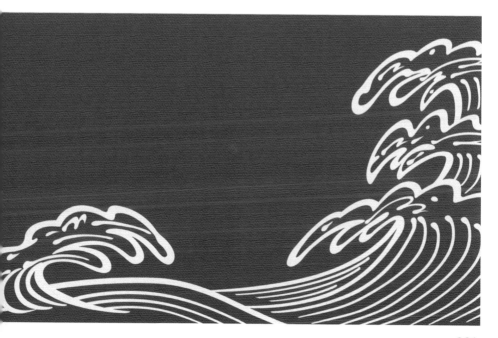

Rough Waves (*Hatou*) - 2

The representations using rough wave designs tend to be rather exaggerated and the image can become rather messy. It is both enjoyable and difficult to create a beautiful design by capturing the momentary movement of various kinds of waves – rough waves, sweeping waves or the splash of waves breaking. The traditional designs in the *Hatou* patterns provide many opportunities to learn about the level of restraint in designs.

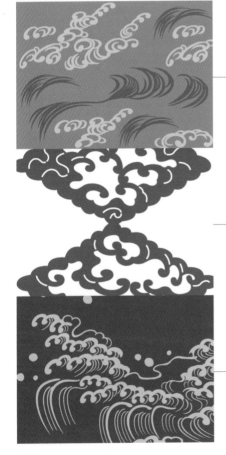

▶ Waves on a narrow-sleeved *Chirimen-Yuzen* kimono

● CD 01-026

This is an expression that embodies warmth and fine workmanship in the portrayal of the breaking waves on both sides that appear to be captured in an instant and pasted on the page.

◀ Waves on gaily colored paper

● CD 01-023

This is a rather complicated expression but the way that the design has not been scaled-down is attractive.

◀ Waves in a dyed pattern

● CD 01-024

This arrangement of waves that looks like a crest appears to have the aim for usage in a continuous pattern.

◀ Waves on a narrow-sleeved kimono in embroidered figured-satin

● CD 01-025

A design that expresses the beauty of the rising wave-crest movement.

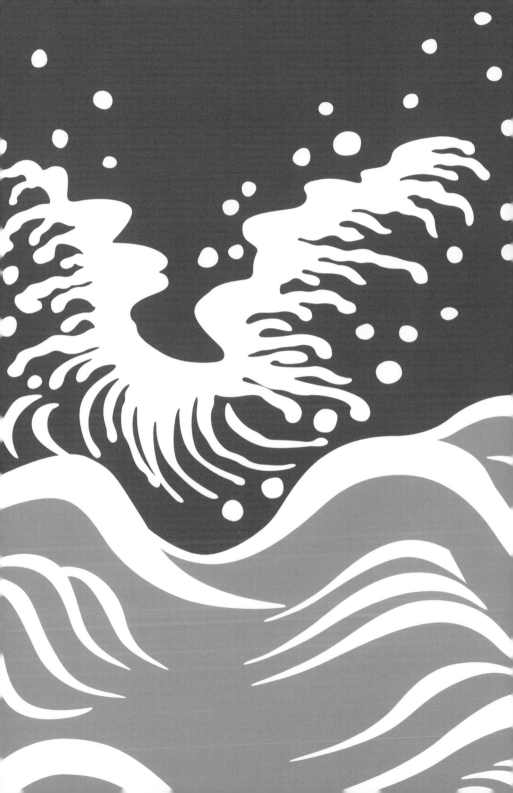

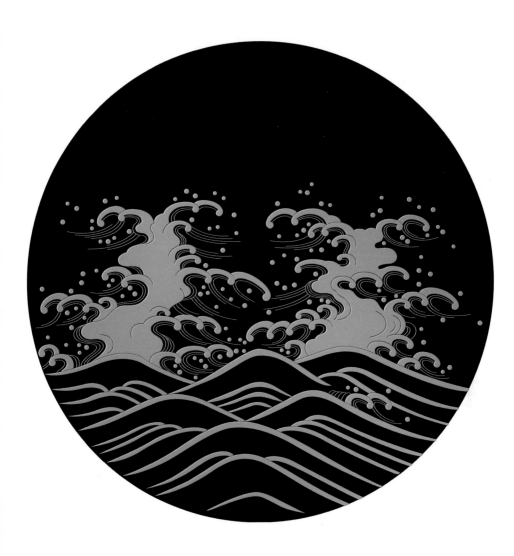

▲ **Rough waves on gold-lacquered water jug** ● CD 01-027

The symmetrical structure of the two *Hatou* waves that appear to be interacting with each and the discordance of the waves show fine workmanship.

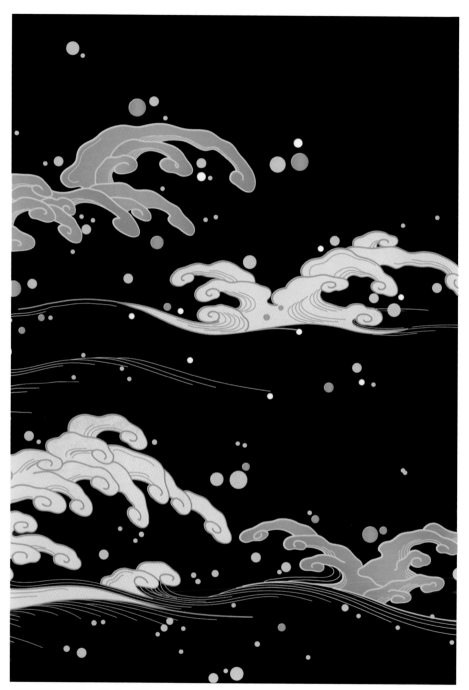

▲ **Gold-lacquered tiered food container** ⬤ CD 01-028
This depiction is superb. It captures the crest of the wave at the very moment that it is about to break.

Wave Shapes and Wave Crests - 1

You can be amazed by the diversity of designs if you take only the crest of the wave from the traditional wave patterns and examine it in detail. The precise shape of the crest of the wave is always in concert with the line of the wave's undulation. There are two methods used to express waves. There is the way of letting the line of the swell play the leading role or alternatively the position of the crest of the wave can determine the line of the swell. There are a lot of hints for creating wave shapes and wave crest patterns contained in traditional designs.

▶ **Embroidered waves on fabric**

◉ CD 01-032

As this pattern emphasizes other motifs apart from waves, the impression of the waves themselves is a little weak. However, there is a certain appeal to the composition of the wave shapes and wave crests.

◀ **Waves on a decorative fitting**

◉ CD 01-029

At first glance this design seems to be arranged like a crest but it does actually keep to the dynamic representation of the rough waves.

◀ **Waves on *Chirimen* fabric for narrow-sleeved kimono**

◉ CD 01-030

This is a totally original expression of wave shapes and wave crests.

◀ **Waves on *Chirimen-Yuzen* narrow-sleeved kimono**

◉ CD 01-031

This conveys the powerful feel to the waves as well as being an elegant wave crest design. It is an expression that conforms to the original form of the traditional design.

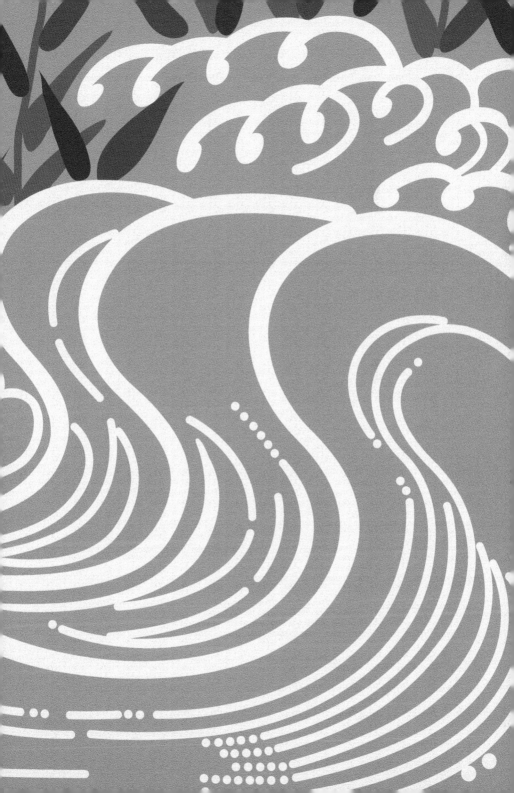

Wave Shapes and Wave Crests - 2

Traditional patterns provide a lot of hints for the development of designs. By examining the details of the traditional wave designs it becomes clear that Japanese certainly excel at observing nature. Also, the designs show the delicate development of the senses having progressed from realistic images to universal patterns. Relief carving can be developed from these designs.

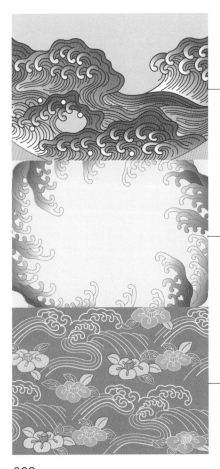

▶ **Big Waves by *Kohren***

◯ **CD 01-036**

These big waves by *Kohren* are extremely well-known. Perhaps due to this fact, the impression of this design is so strong that when we see these waves on a background wall in a drama the foreground becomes blurred.

◀ **Wave crests on a large *Nabeshima* dish**

◯ **CD 01-033**

It may be barely perceivable but the pull of the tide is expressed by the rippling waves created by just a few wave crests.

◀ **Multi-colored over-glaze painting of a wave on a dish**

◯ **CD 01-034**

The plates with pictures made in the Nabeshima domain furnaces used a high level of precision and conformed to a high level of aesthetic standards. In addition, these waves that are painted on the edges combine to produce a modern design feel.

◀ ***Kaga-Yuzen* waves**

◯ **CD 01-035**

The background to the main pattern shows waves that are drawn with lines of two different thicknesses. It is an elegant pattern.

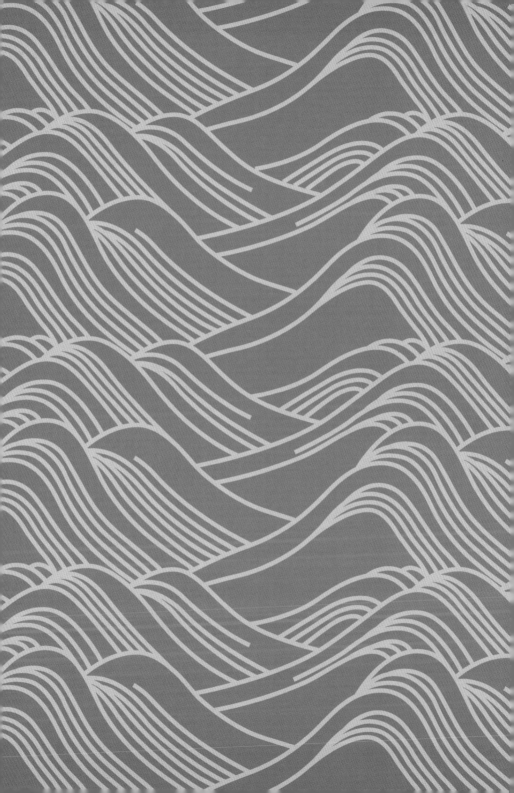

Flowing Water - 1

Since ancient times flowing water designs have been used in a wide variety of designs on cultural artifacts and represent very important material from among the Japanese traditional designs. However, it is extremely rare to see solely an expression of flowing water by itself. The reason for this is because in aesthetic tradition Japan is known as "the Land of Abundant Reed Plains and Rice Fields" and water is therefore an essential background feature, together with waterside birds, flowers and grass. It brings warmth and depth to the design.

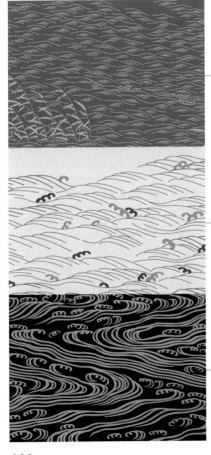

▶ **Waves on a Noh costume**

⬤ CD 01-040

The waves in this design can create the mood for formative development through the consistency of the main design.

◀ **Waves on a narrow-sleeved *Nandoji* kimono**

⬤ CD 01-037

The subtle shape of these tiny waves effectively conveys the rippling effect.

◀ **Waves on a narrow-sleeved *Nuihaku* kimono**

⬤ CD 01-038

The randomly placed colored wave crests among the waves creates an elegant accent.

◀ **Small gold-lacquered case**

⬤ CD 01-039

The linked lines are neither uniform nor broken. This continuous pattern effectively creates the image of flowing water.

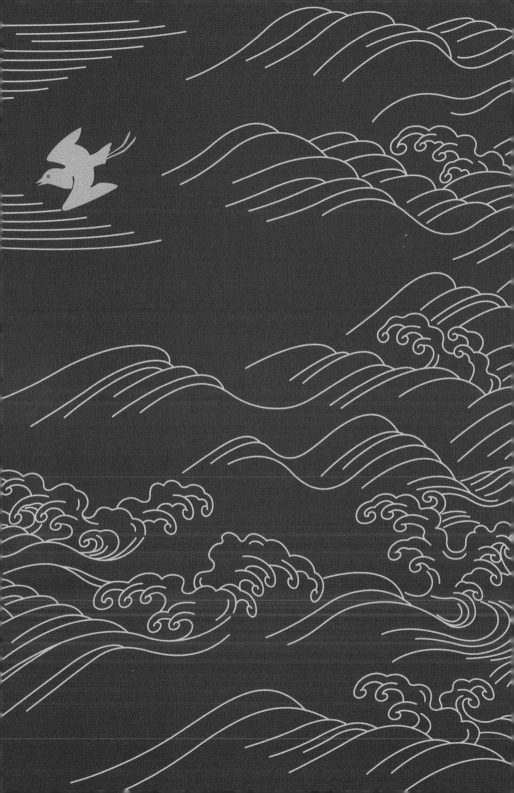

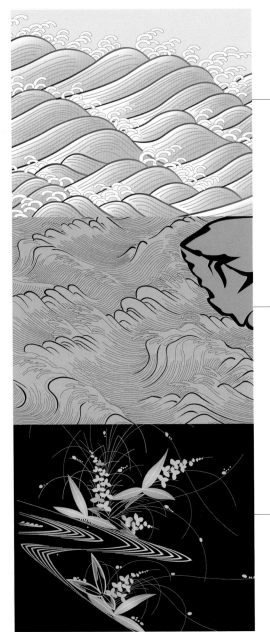

▶ Tie-dyed whirlpools on short-sleeved kimono

● CD 01-044

The vortexes are created by using an intricate tie-die technique. They have a depth that is not monotonous.

◀ A section of waves in a good fortune picture at *Kuwanomi* temple

● CD 01-041

Although this is a picture, the contrast between the waves and the crests of the waves lend it design quality.

◀ A section of waves on *Kegon* good fortune picture

● CD 01-042

This is a realistic wave design that was used to illustrate the content of stories from ancient times.

◀ A lacquer painting on a tray of an angular wave pattern

● CD 01-043

This is a kind of transformation of a wave pattern. The intensity of the picture conveys proof of the formative power of the design.

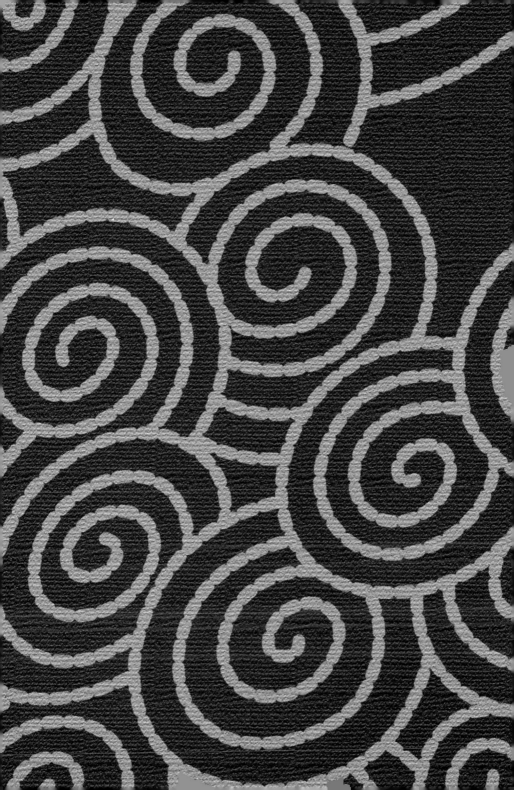

Flowing Water - 2

When we look at elegantly flowing curved lines we feel relaxed and can feel somewhat released from tension. We need to perceive comfort and beauty and not feel that our feelings are bothered by the things that are always near to us and at times in our direct view. Traditional designs, showing flowing water, are brimming with a well-balanced beauty and a sense of openness.

▶ **Flowing Water on Kimono Cloth**

⬤ **CD 01-048**

This is a flowing water pattern on ancient cloth. The pattern has a sense of both continuousness and freedom and offers the opportunity for development.

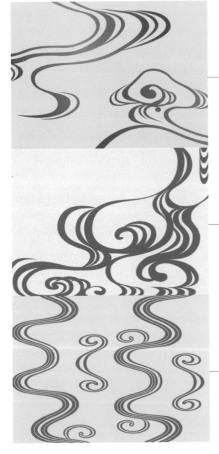

◀ **Waves on *Kaga-Yuzen* short-sleeved kimono**

⬤ **CD 01-045**

The movement of the flowing water has been developed into a highly original form.

◀ ***Kenzan* colored over-glaze painted flowing water on a square dish**

⬤ **CD 01-046**

The curved lines that never stagnate convey the sense of an open world view.

◀ ***Miyako-Jyoufu* fabric flowing water design**

⬤ **CD 01-047**

This design has a cool and pure feel to it and is another unpretentious representation of flowing water.

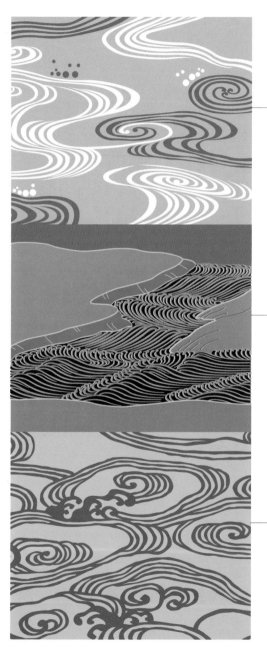

▶ Waves on a gold-lacquered relief on a large lid

⊙ CD 01-052

This flowing water pattern is a representation of a refined flowing pattern that is often seen in gold relief along with colored autumn leaves and cherry blossoms.

◀ Floating- chrysanthemum pattern used on *Nuihaku*

⊙ CD 01-049

The floating-chrysanthemum pattern is seen so often that it could almost be called a kind of form on its own. This is one example of the elegant flowing water style of the floating-chrysanthemum.

◀ Flowing water gold-lacquered relief on a box for mirrors

⊙ CD 01-050

This design expresses a bold presence through the small waves rising in the clear stream flow that divides the field to the left and right of the picture.

◀ Dyed pattern of waves

⊙ CD01-051

The spread of the free curved lines is rich in suggestion of continuity.

▲ Gold-lacquered relief of flowing water on a *koto* (*Sou*) ● CD 01-053
This is a heavy and dignified design. It gives a finish similar to the flow of the wood grain and is suitable as a design on a *koto*.

▼ Waves on *Sukashibori* (openwork) comb ● CD 01-054
This is a small work of art presenting a design that superbly expresses natural beauty in the scene combining waves and scattered flowers.

Flowing Water - 3

These "flowing water designs" with their smooth curved lines are very appealing to anyone looking for the sense of attractiveness in a design. This is also because these curved lines express an image of pure flowing air and fluctuating emotions. There are many points that can be learned from the elegantly flowing curved lines of traditional patterns whether they be used as the main design or whether they play a supporting role by adding depth to a design.

▶ **Copper mirror water crest**

◉ CD 01-058

Rather than trying to portray the wave on the whole surface this design uses the wave pattern on part of the surface in an original way.

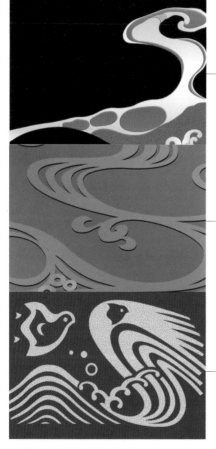

◀ **Flowing water in gold-lacquered relief on an ink-stone case**

◉ CD 01-055

This pattern of flowing water is a little different and original. It could also act as a guide for approaching design development.

◀ **Flowing water on engraved on metal fittings**

◉ CD 01-056

This is a familiar design that could be used as a model for flowing water designs.

◀ **Plover crest cotton cloth waves**

◉ CD 01-057

This is a unique design. If it is made smaller the structure of the waves appears like the unified arrangement in a crest design.

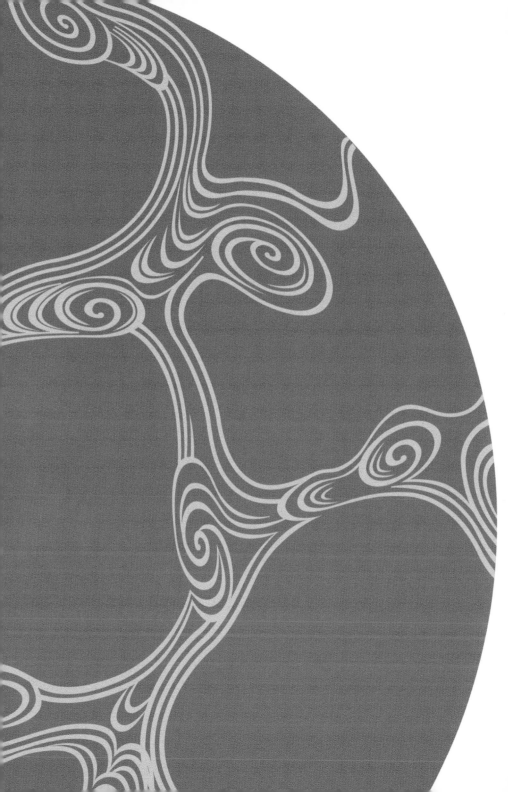

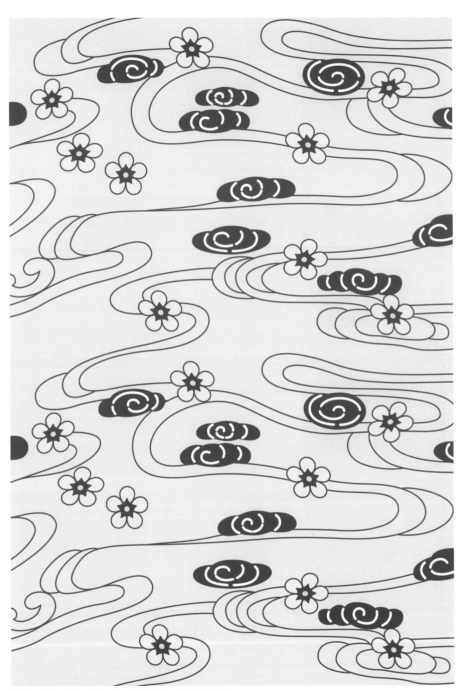

▲ *Kogasuri* traditional flowing water design ● CD 01-059
Due to the use of color in the design, the flowing water conveys the atmosphere of a sweet young girl.

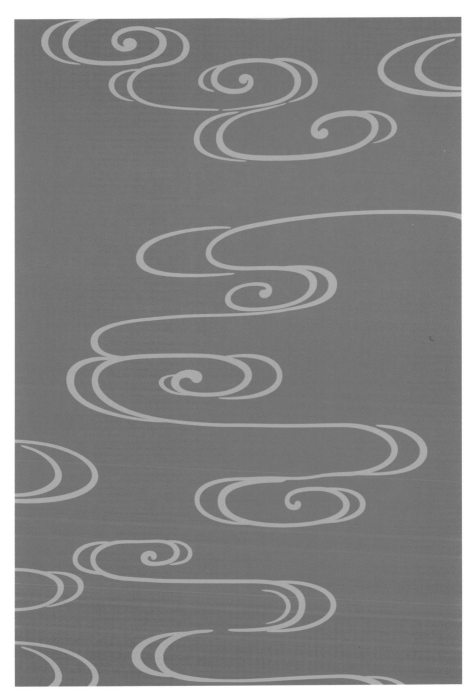

▲ Flowing water pattern on Noh costume material ● CD 01-060
Although this is a *Kanze* water pattern it is beautiful flowing water. The curved lines are mellow and refined.

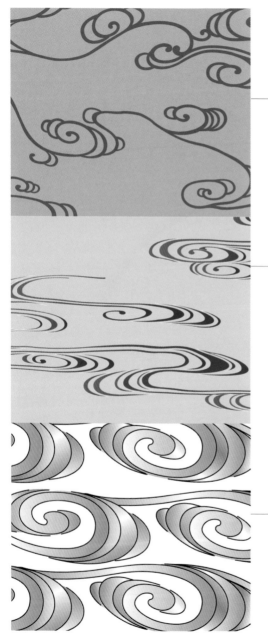

▶ Flowing water gold-lacquered design
on shelf-doors

● CD 01-064 CD 01-065

Elegant and ornate flowing water. It is a dignified and
well-established form.

◀ Dyed wave pattern

● CD 01-061

This is a line-drawing with a lot of space. However, that
is probably due to the emphasis on the continuous nature
of the composition.

◀ Flowing water on *Kaga* dyed
narrow-sleeved kimono

● CD 01-062

The appearance of flowing water in an idyllic setting.

◀ Flowing water in *Imari* arabesque pattern

● CD 01-063

The decorative lines give a depth to the continuous
pattern of vortexes.

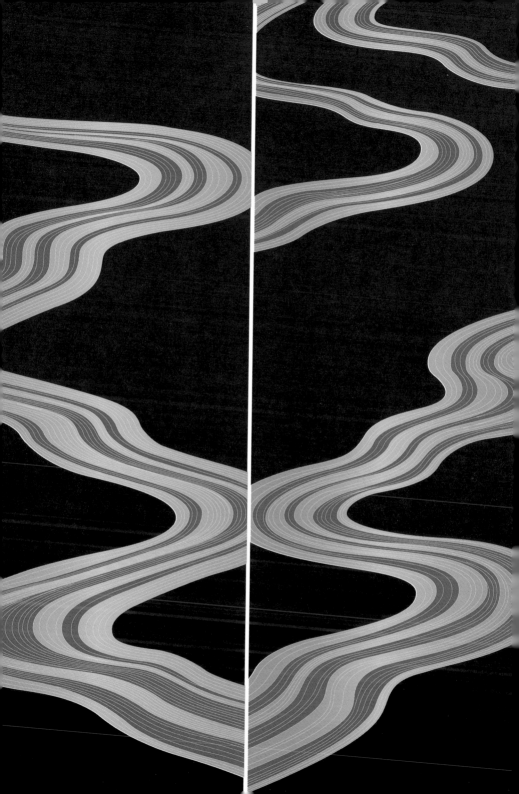

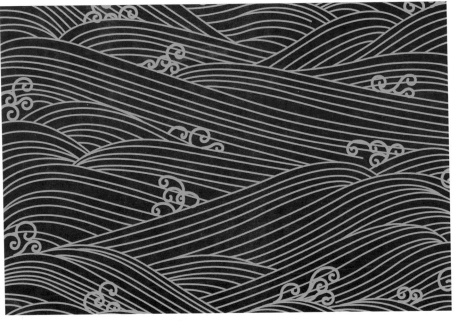

▲ **Illustration of waves on an ink-stone case** ● CD 01-066
This has to be classified as a "wave" pattern but when referred to for the drawing of fine lines it looks more like a "flowing water" pattern.

▼ **Waves on colored paper** ● CD 01-067
The same as design number 66, this pattern could be a river or the sea but this pattern is a famous wave design drawn with fine lines.

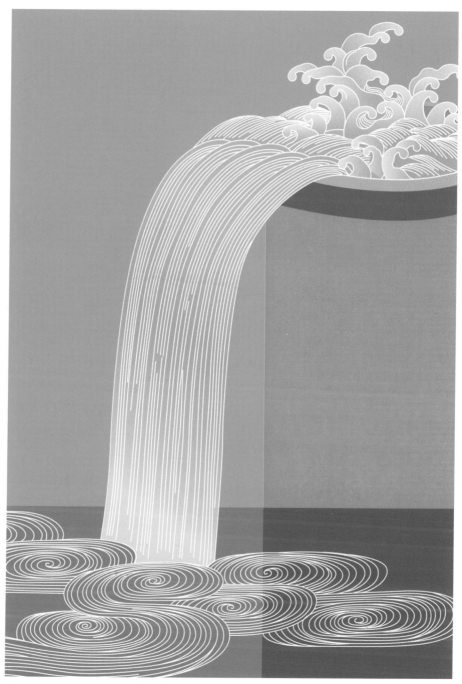

▲ Auspicious pattern of flowing water ◉ CD 01-068
The appearance of the falling water forms a design that is quiet and composed without realism.

▲ **Flowing water on *Karuta* (card game) book** ● CD 01-069
Although it does not appear to be much, the movement of the water breaking as it circumvents the obstacles makes good reference material.

▼ **Illustration of a wave on a tray** ● CD 01-070
There is a cultivated charm to the movement of the water, the weeds and the fish that follow the shape of the utensil. It is a unique representation.

Chapter 2
Cloud Patterns
CD 02：071-120

Japanese character 工-shaped clouds

Clouds symbolized by the Japanese katakana character "工". Although the shape of "工" is more often seen in mist designs it is actually difficult to distinguish between clouds and mist in representations. In this chapter we have selected the special features of designs that depict natural phenomenon that occur in open nature such as "工 mist" traditional patterns and "boiling clouds." "工-shaped clouds" are also known as "a bank of clouds." The forms in these designs are often used as material to express dampness in the air and the shapes create the graceful emotional atmosphere of Japan.

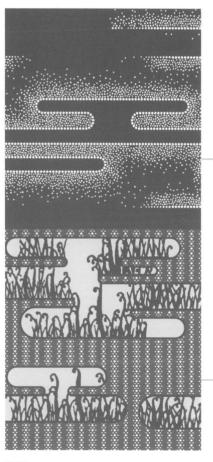

▶ Dyed pattern of clouds and pampas grass (*Susuki*)

🔘 CD 02-073

There is also an expression of a motif enclosed in the "工" of this design.

◀ "工mist" on a small crest

🔘 CD 02-071

The special features of a small crest design are brought to life by the small circles that appear to be drilled into the pattern creating the dream-like appearance of the "工 mist."

◀ Dyed pattern of clouds and bracken

🔘 CD 02-072

The motifs are added to create a simple finish to the "工 -shaped clouds."

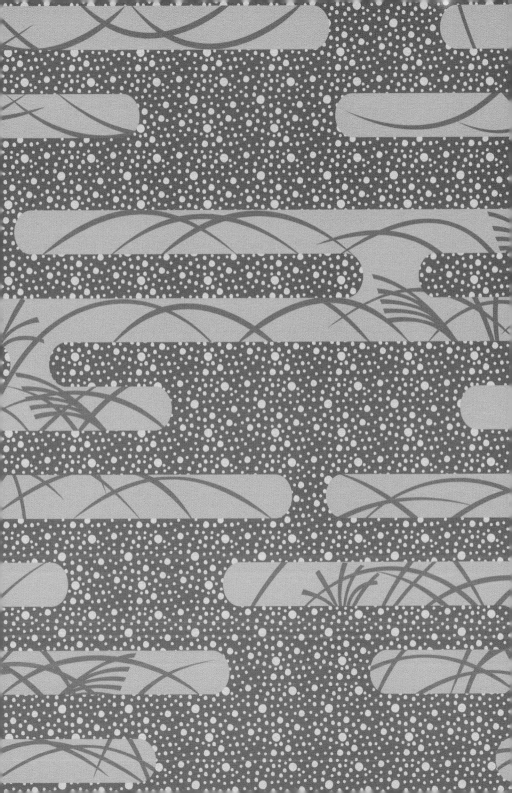

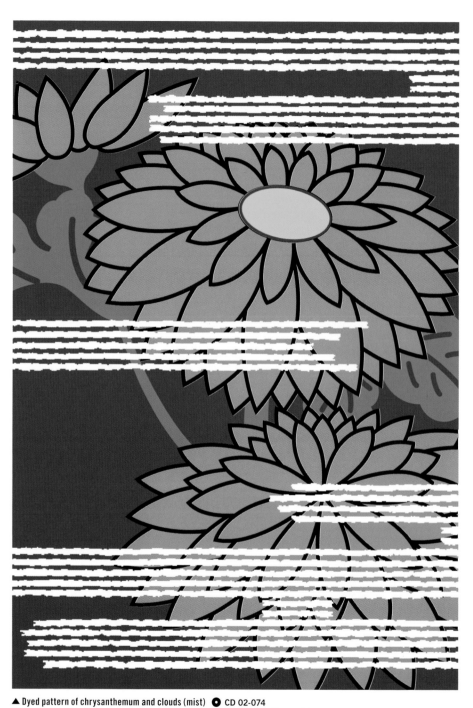

▲ **Dyed pattern of chrysanthemum and clouds (mist)** ● CD 02-074

This design shows the shape of a gradual development of エ-shaped clouds (mist) by use of the distinctive lines.

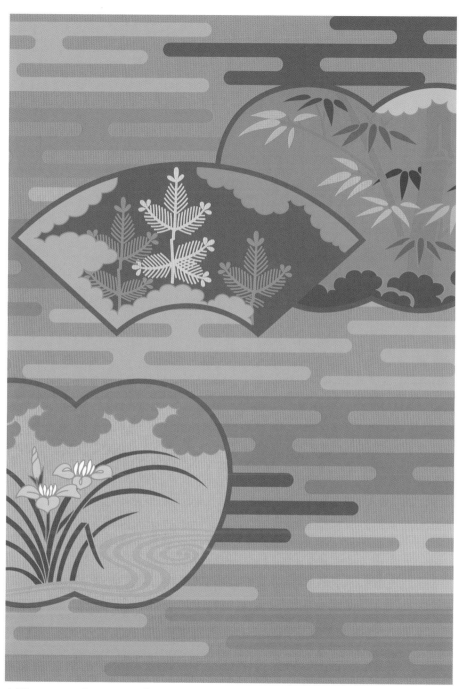

▲ **Chinese weave on Japanese fans** ● CD 02-075
Both clouds and mist often play the role of creating the atmosphere although their motifs are in contrast with each other.

Genji Clouds

The "*Genji* clouds" are often seen in the Heian picture scrolls and got their name from that elegant form. There are hardly any examples of clouds being used as the main part of a design composition. Clouds are drawn in designs to achieve creative effects; for example, the picture may be set off by the shape of clouds to bring a sense of distance to the design. In this way the use of *Genji* clouds is very convenient to bring a sense of harmony ("*wa*") to the composition of the picture. When using traditional designs as reference material their capabilities become apparent.

▶ *Genji* clouds on *Yuzen* narrow-sleeved kimono
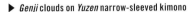
● CD 02-078
Using the power of brightly colored elements to portray attractive clouds.

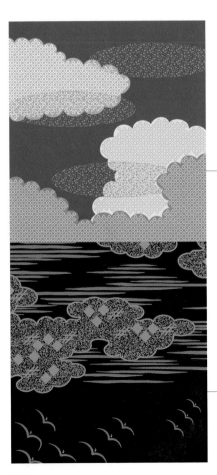

◀ *Genji* clouds on cloth
● CD 02-076
This is a colorful composition of *Genji* clouds. Although simple, the design has a sense of elegant refinement.

◀ Illustration of *Genji* clouds on a case
● CD 02-077
This design, with its composition of line clouds and clouds in the foreground, expresses a calm and quiet scene.

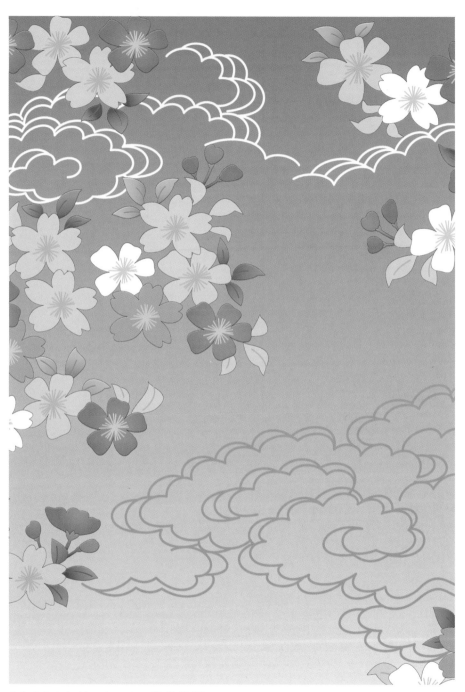

▲ *Genji* clouds dyed in various colors ● CD 02-079
The line-drawn clouds create a bright and peaceful hazy sky.

▲ *Genji* clouds in *Kyoto Yuzen* pattern ● CD 02-080
The way the clouds are embellished in the design represents a comparatively new transformation of the *Genji* cloud pattern.

Auspicious Clouds (*Zuiun*)

The swirly shape of this cloud originating in China expressed an auspicious omen. As the shape resembles a kind of mushroom called the Reishi mushroom, it is also called the "Reishi mushroom cloud." There are many ways to develop this cloud pattern depending on such factors as the number of lines, surfaces and swirls. But whichever way the design is modified, it still remains an "auspicious cloud" pattern. That shows just how distinctive this cloud pattern is.

▶ **Auspicious clouds on a kimono slip**

◉ **CD 02-084**

This design shows the use of ingenuity in the gold thread tracing the contours of the clouds.

◀ **Auspicious clouds in a line design**

◉ **CD 02-081**

This demonstrates a definite form. This method shows the potential for further development.

◀ **Auspicious clouds on a costume design**

◉ **CD 02-082**

Simple auspicious clouds appear to be transformed by only a slight color variation.

◀ **Auspicious clouds on a costume design**

◉ **CD 02-083**

The layered effect of the colored clouds is created from an archaic design. The background is a lightning (zig-zag) pattern.

▲ **Auspicious clouds on thick board** ● CD 02-085
The lightning in the background is beautiful and full of vigor. For that reason the auspicious clouds appear a little feeble.

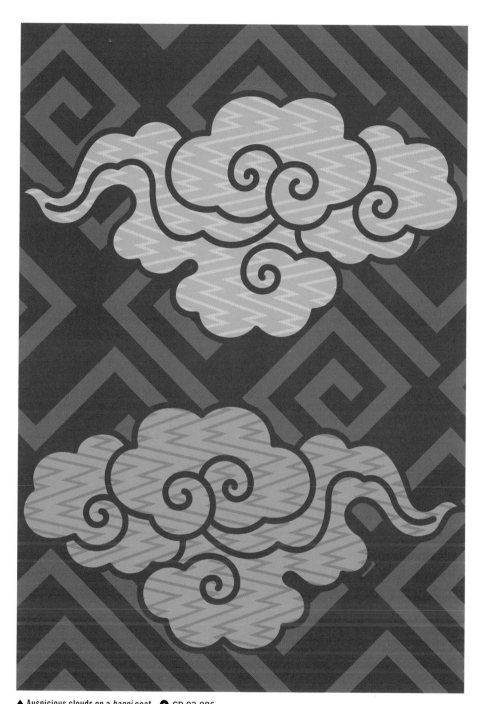

▲ Auspicious clouds on a *happi* coat ◐ CD 02-086
Both stately and profound, the design brings out the true auspiciousness of this cloud pattern. The background is a lightning (zig-zag) pattern.

Kumodori (cloud-shaped patterns arranged upon a larger picture)

Like the *Genji* clouds, the pattern formed by repeating the shape of the arc is called *"Torikei"* (creating the shape.) *Kumodori* design is a layered arrangement of pictures applying clouds in an outstanding supporting role. Through the use of the cloud motif, with patterns contained both within the cloud and placed outside the cloud shape, patterns can be used freely to create the main design and the technique can be applied to develop a wide range of designs.

▶ **Dyed *Yuzen* colored clouds**

⊙ **CD 02-090**

The arc of the cloud shape forms a crescent shape. The clouds can be used in an endlessly repeated layered arrangement. With features such as the pictures inside the clouds, this *kumodori* design satisfies the requirements for pattern development material.

◀ **Kyoto *Yuzen kumodori* design**

⊙ **CD 02-087**

This is a design with a modern feel. It demonstrates the free development of a design through the doughnut-like shapes attained by the assembly of the cloud arcs.

◀ **Kyoto *Yuzen kumodori* design**

⊙ **CD 02-088**

The design is brimming with a happy feeling that could be compared to listening to a cheerful song. This is achieved by the contrast between the large, freely floating clouds and the scattered emblems of intricate flower patterns.

◀ ***Kumodori* design in scarlet**

⊙ **CD 02-089**

This is full of bright color with a continuing random arrangement of clouds. Use of the cloud shapes gives the effect of a non-contrived, distinctively colored surface-composition.

Boiling Clouds
(*Kumotatewaku*)

Boiling clouds prominently stand out as one of the most brilliant patterns among the traditional designs. The way that the appearance of the clouds rising in the sultry atmosphere is visually portrayed creates a feeling of affinity with the clouds and helps the moving cloud patterns become one of the warmly familiar patterns from among the traditional designs.

◀ **Boiling clouds on a costume design**

⭘ CD 02-091

This is a perfect example of making a single design from the boiling cloud image simply by overlapping the fixed shape of the clouds.

◀ **Boiling clouds design on *Sashinuki***

⭘ CD 02-092

Sashinuki were *hakama* worn by nobles. The design of these rather large clouds, in comparison to design number 093 (below), gives the image of being complete.

◀ **Boiling clouds on *Akome* (innerwear)**

⭘ CD 02-093

The shape of these clouds resembles the flame of the *Kaendaiko* drums. It gives a slightly archaic impression but is elaborately arranged. *Akome* were worn by nobles as under-clothing.

Decayed Tree Clouds
(*Kuchikigumo*)

These decayed tree clouds have the appearance of the bark of decayed trees. Just like "mackerel sky" they have been named in a descriptively straightforward way. This design can easily be used in a continuous pattern and as it does not have any detailed design specifications it can developed freely with imagination: it can be made bigger or smaller or more detailed, graceful, anxious or cordial. It is a cloud design that facilitates the development of various expressions.

◀ Decayed tree clouds on Kyoto *fusuma* paper
○ CD 02-094

Although the clouds in this design are not very realistic, they do give a strong impression.

◀ Decayed tree clouds on Kyoto *fusuma* paper
○ CD 02-095

These clouds are realistic and convey a sense of constraint in the design.

◀ Decayed tree clouds on Kyoto *fusuma* paper
○ CD 02-096

As a result of the way the design is arranged, a unique design has been created from both the clouds and the refreshing feel to the atmosphere.

Cloud Shapes (*Kumogata*) - 1

The unaffected beauty created by nature remains the same, whether now or long ago. People used to give everything under the sun a name in order to feel a sense of familiarity. This practice continues even at the present time. When they saw a cloud shape they would draw a connection and name it even if it was not exactly the same as the shape they had identified it with. Even now it is desirable to retain that level of sensibility and never overlook even a slight change of shape. This is a collection of various cloud images portrayed by brushstrokes and taken from ancient hand-written materials.

◀ **Rain clouds (small spots) on small design**

⦿ CD 02-097

The small patterns that look like they have been drilled express the splashing of water from footsteps. The solidly colored part expresses the thickness of the clouds. The design shows a skillful ability to portray a scene.

◀ **Rain clouds (dyed pattern)**

⦿ CD 02-098

The flexible shapes of the clouds do not convey a sense of the design being contrived. The three lines representing rain demonstrate humor and intelligence in regards to design development.

◀ **Rain clouds (ancient materials)**

⦿ CD 02-099

Soon after the loud thunder that seems to cut through the earth the late afternoon rainstorm seems to be coming along with the clouds that gather and float together.

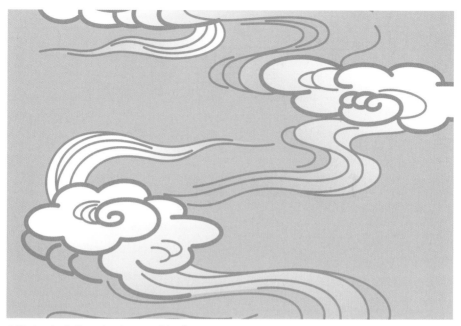

▲ Flowing clouds (*Ryu-un*) ancient materials ● CD 02-100
This is an attractive design with elegant curved lines that appears to express the dancing movement of the clouds caused by the blowing wind.

▼ Flowing clouds (*Ryu-un*) gold materials ● CD 02-101
These flowing thin clouds, woven of gold thread, are an itsselegant and refined expression.

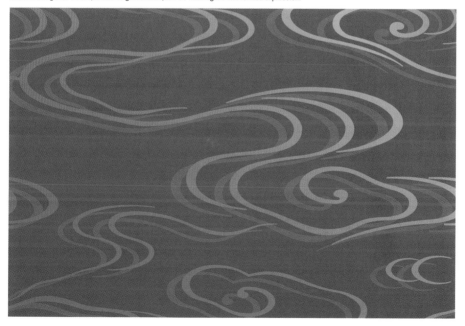

▲ **Flowing clouds on a narrow-sleeved kimono** ◉ CD 02-102
The wispy flowing clouds are depicted by the stylish lines.

▼ **Flowing clouds on a costume design** ◉ CD 02-103
There is a graduation in the area of the surface from thick to thin lines. These flowing clouds convey an impression of time.

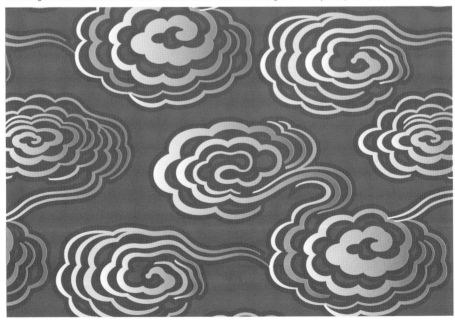

Cloud shapes (*Kumogata*) - 2

In the Edo period there was a movement away from the previous concentration on woven textiles to a focus on dyed material and naturally the demand for dyed patterns also increased. Patterns for dyeing from every kind of natural scene and pictures from every genre have been preserved. However, almost all of them are brush-drawn line-pictures by designers of those times. Also, many of them are partially sketched or drawn on impulse, evidence of the creative power behind the ideas of the dye craftsmen.

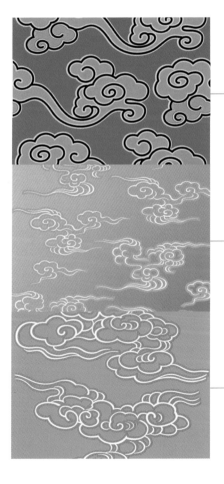

◀ **Moving clouds on a building**

◯ CD 02-104

This is a decorative cloud pattern on a building wall. Whilst respecting the ancient formal style, it forms a modern continuous pattern of clouds.

◀ **Flying clouds (*Hiun*) from ancient materials**

◯ CD 02-105

The clouds are whipped up and broken into pieces by the wind. This portrayal is brimming with a sense of movement.

◀ **Cloud diffusion (*Sanun*) from ancient materials**

◯ CD 02-106

A design that seems to show a close-up of the appearance of ragged clouds. Its resemblance to the design structure of flying clouds may be unsurprising

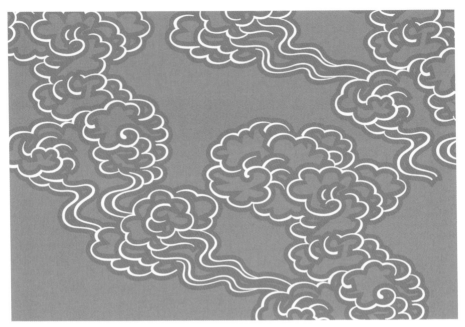

▲ Summer clouds (*Natsugumo*) from ancient materials ⬤ CD 02-107
A solid mass of rising summer clouds. The lines rather than the surface make this design a touch different.

▼ White clouds (*Shirogumo*) from ancient materials ⬤ CD 02-108
White trailing clouds that do not convey an impression of thickness. Skill is shown by the sense of speed in the design.

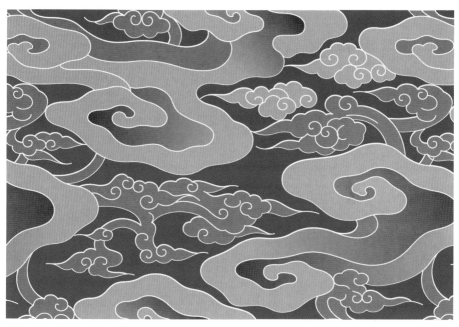

▲ Big and small clouds (*Komochigumo*) from ancient materials ● CD 02-109

Although this design may have a rather old-fashioned appearance to it, it can be used to learn something about dynamic depiction.

▼ Rising and falling clouds (*Shoukouun*) from ancient materials ● CD 02-110

The structure of the clouds demonstrates how this design has been developed to depict clouds rising and falling.

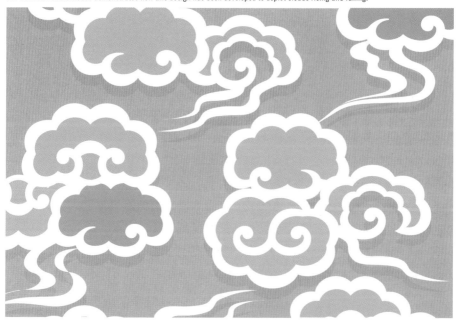

Cloud Shapes (*Kumogata*) - 3

Sketches and impulsive patterns that took a lot of effort to draw by hand with a brush naturally undergo quite a transformation when it comes to the dyeing stage. Also, lines that are drawn using a computer nowadays (Bezier lines) demonstrate an even greater transformation. Rather than focusing on the features of the brushstrokes and saying, "the lines are different to those in the reference material," the point to learn here concerns the actual ideas behind the creation of the design. Moreover, these designs should not present limitations and the production of their special features using a brush can be treated as a separate issue.

▶ Fixed shape clouds (Large cloisonné clouds *Shippotaiun*)

⬤ CD 02 -114

This is an elaborate and noble design with a diagonal pattern.

◀Woven clouds from ancient materials

⬤ CD 02-111

It is unclear exactly which part of this cloud is woven and the kind of weave used.

◀Cloud pattern

⬤ CD 02-112

This is a popular cloud pattern that is often used even now. It is a simple and uncomplicated design.

◀Fixed shape of clouds on Noh costume

⬤ CD 02-113

A cloud pattern that has the qualities suitable for use in a Noh costume. It is a noble design.

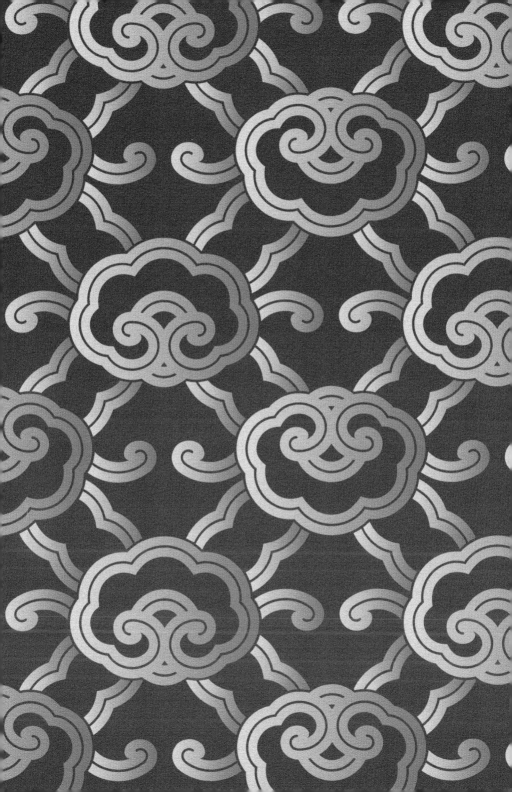

▶ Dyed pattern of wild geese on clouds

◉ CD 02-118

The freely carved design creates a tasteful atmosphere.

◀ Decorative cloud on the front of a helmet

◉ CD 02-115

Auspicious clouds carved in gold. A dignified and composed design suitable for armor.

◀ Cloud decoration (Full moon cloud swirls)

◉ CD 02-116

The same kind of auspicious clouds. A woven pattern often seen on the *kariginu* clothing of the nobility.

◀ Stitched continuous mist pattern

◉ CD 02-117

Although this pattern does not appear to have much to it, the lines show a tasteful flow.

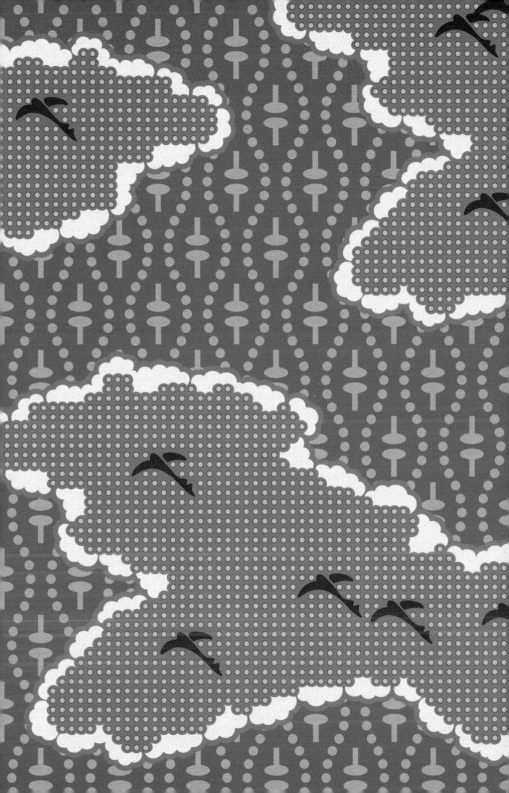

▲ Small chrysanthemums around clouds (*Yuzen*) ● CD 02-119
The dapple-patterned clouds of various shapes are not just clouds; they fill the design with an atmosphere of intense gentleness.

▼ Mist design on a Noh costume ● CD 02-120
The mist breaks up the colored foreground. The design looks simple but it stays within the conventions for cloud expressions.

Chapter 3
Continuous Wave Patterns
CD 03:121-210

Continuous *Seigai* Waves

As demonstrated in the chapter about *"Seigai* waves" in chapter one, there is no limit to the ways that the traditional *Seigai* wave designs can be developed. They can be transformed in complex ways to match the specific features of the design such as: 1. Simple repetition of the wave pattern. 2. Changes to the shape or form of the waves. 3. Brushstrokes added to parts of the wave. 4. Negative and positive transformations to the wave. The choice of color tones is swayed by the level of influence the *Seigai* waves have in the design. The best method is to try out various simulations from plain color to complex tones after creating an appropriate sized area of continuous pattern.

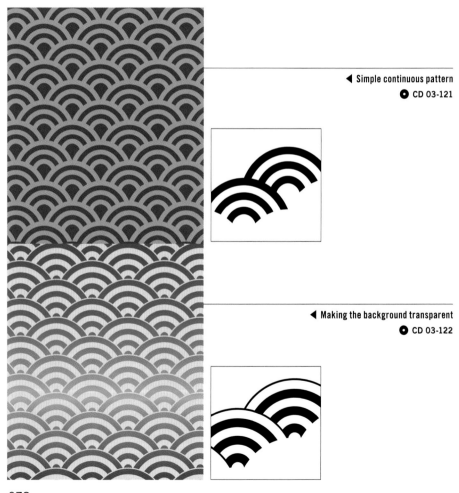

◀ Simple continuous pattern
○ CD 03-121

◀ Making the background transparent
○ CD 03-122

▶ Development of the wave shape
● CD 03-123

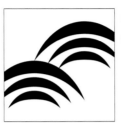

▶ Development of the wave shape/delicate
● CD 03-124

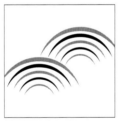

▶ Development of the wave shape/gentle
● CD 03-125

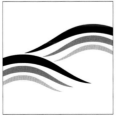

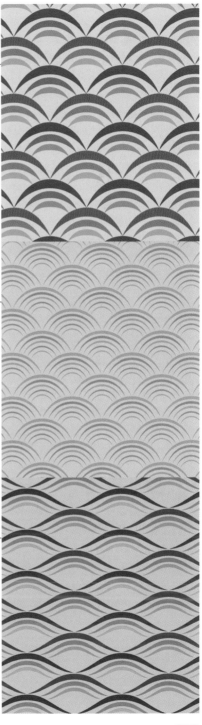

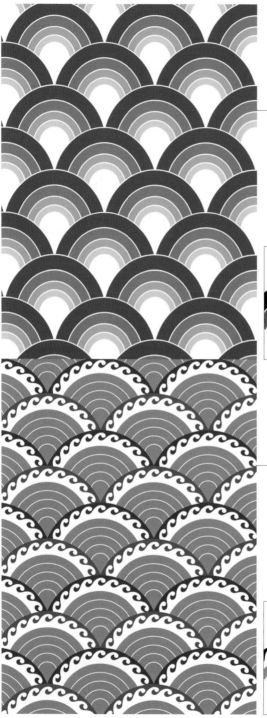

◀ Development of the wave shape/elongated
○ CD 03-126

◀ Adding brush strokes to part of the wave
○ CD 03-127

▶ Waves transformed into pictures
⬤ CD 03-128

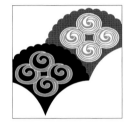

▶ Realistic waves
⬤ CD 03-129

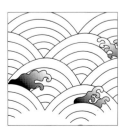

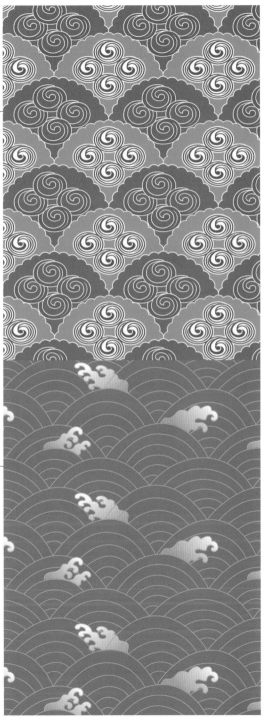

Continuous *Kanze* Water and Flowing Water Patterns

Both *Kanze* water patterns and flowing water patterns were created with the original intention of their application in continuous designs. One of the most outstanding features of traditional patterns is their consciousness of space. Prominent features of flowing water designs in particular are the creation of naturally-looking designs inspired by images from the world of nature and the development of expressions that do not appear excessive. So that the flow of the water does not appear to be interrupted or blocked it is advisable to use any blank space in the design to convey an impression of the broad reach of the flow, even when composing flowing water designs of only a few lines.

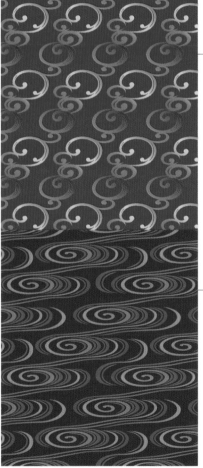

◀ Continuous pattern of large and small single shapes of flowing water

● CD 03-130

◀ Continuous pattern of *Kanze* water development

● CD 03-131

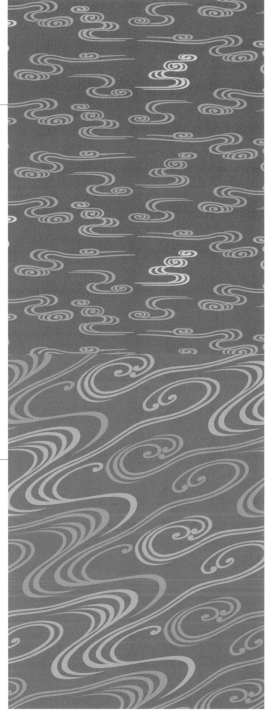

▶ Arrangement of randomly changing
Kanze water swirls

◉ CD 03-132

▶ Continuously unraveling water design

◉ CD 03-133

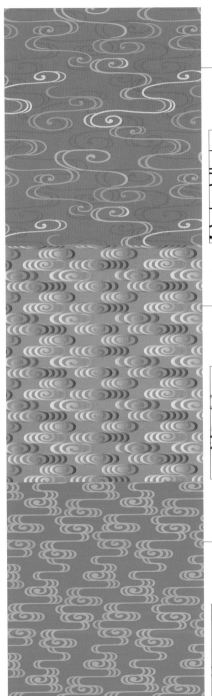

◀ Lineup of changing and unraveling *Kanze* water patterns
 ● CD 03-134

◀ Continuous design of only large and small *Kanze* water swirls
 ● CD 03-135

◀ Development of *Kanze* water design
 ● CD 03-136

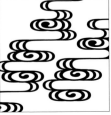

Continuous Wave Crests

Wave crests in traditional wave patterns have a diverse range of shapes. By carefully identifying, extracting and repeating the shape of the wave crests created by the shape of the undulating wave, a continuous pattern is created that can be used for many designs such as woven patterns.

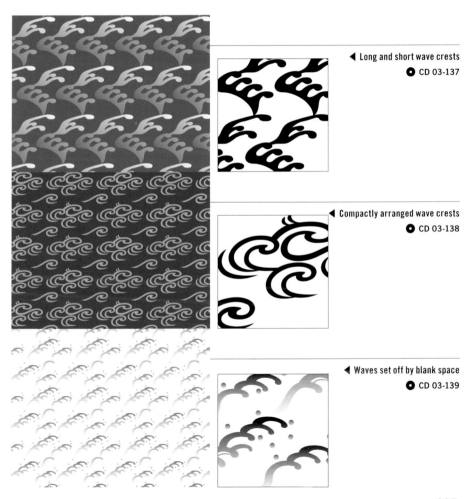

◀ Long and short wave crests
○ CD 03-137

◀ Compactly arranged wave crests
○ CD 03-138

◀ Waves set off by blank space
○ CD 03-139

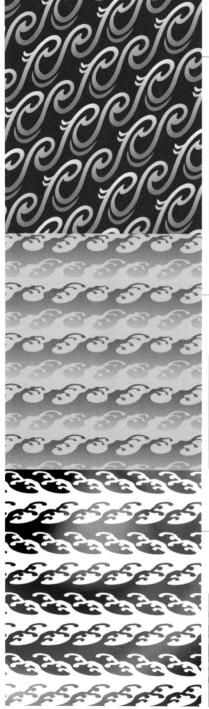

◀ Interesting appeal of the curved lines in wave crests

○ CD 03-140

◀ Wave crests in a positive-negative pattern - 1

○ CD 03-141

◀ Wave crests in a positive-negative pattern - 2

○ CD 03-142

▶ Large and small wave crests
● CD 03-143

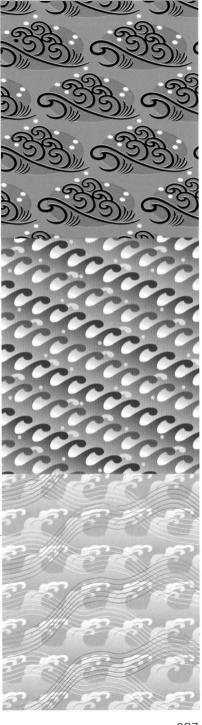

▶ Wave crests in a woven pattern
● CD 03-144

▶ Wave crests with a touch of sea breeze
● CD 03-145

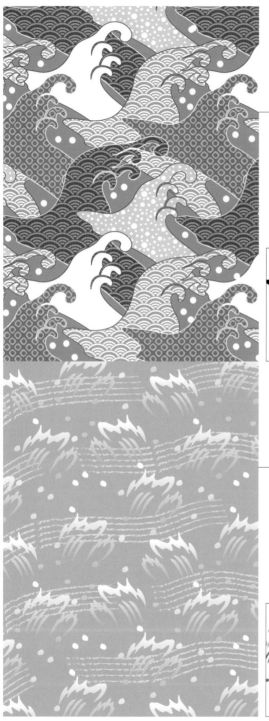

◀ Development of a wave crest design
● CD 03-146

◀ Crashing waves and sea breeze
● CD 03-147

Unification of Wave Shapes and Wave Crests

A continuous design that can be used in woven patterns, for example, can be created by isolating and repeating the shape of the waves and billows. A diverse range of expressions can be produced, from simple to intricate designs. If the image is developed further, the design can be transformed by creating units of the images arranged in lines.

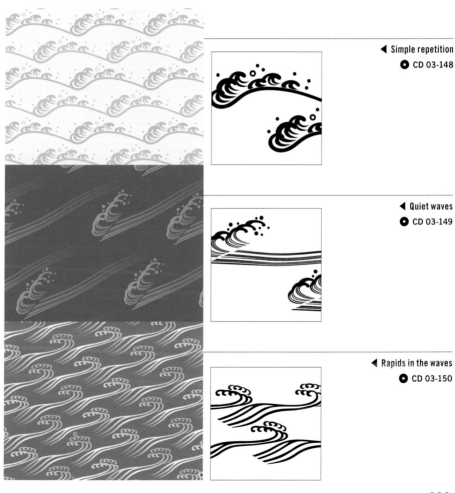

◀ Simple repetition
○ CD 03-148

◀ Quiet waves
○ CD 03-149

◀ Rapids in the waves
○ CD 03-150

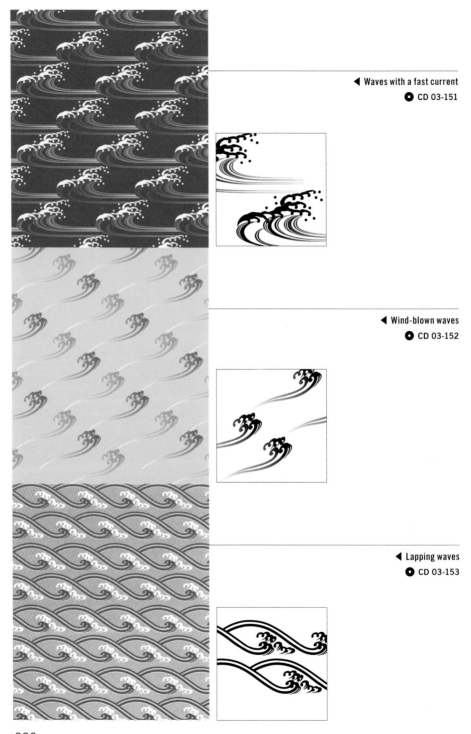

◀ Waves with a fast current
○ CD 03-151

◀ Wind-blown waves
○ CD 03-152

◀ Lapping waves
○ CD 03-153

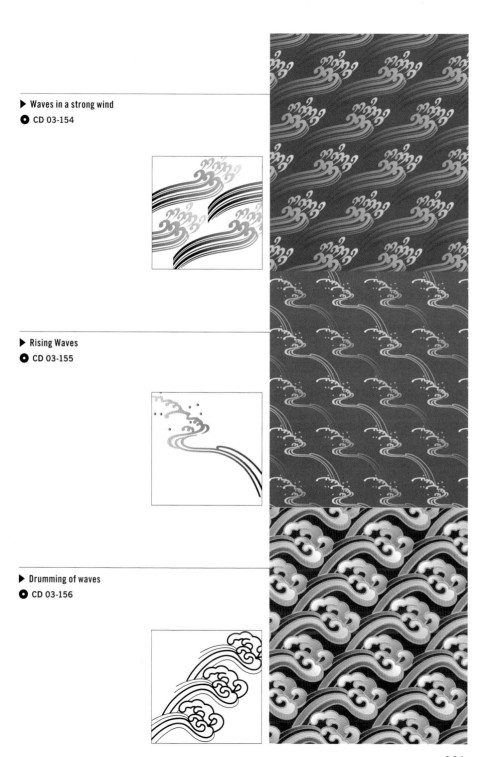

▶ Waves in a strong wind
● CD 03-154

▶ Rising Waves
● CD 03-155

▶ Drumming of waves
● CD 03-156

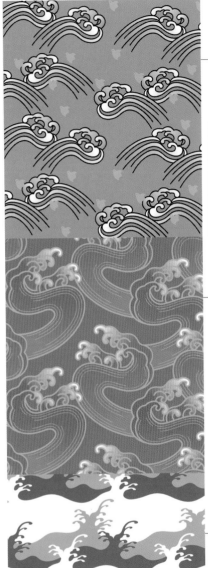

◀ Plovers playing on waves
● CD 03-157

◀ Rough waves
● CD 03-158

◀ Light reflected on waves
● CD 03-159

Emphasis on the Undulation of Waves

Just by arranging random short curved lines into a unit and repeating them in a continuous pattern, the movement and beauty of a scene of undulating waves can be created. By concentrating on the undulation of the waves rather than the crests of the waves and creating a continuous line, when the crests are actually added, a superb effect can be achieved.

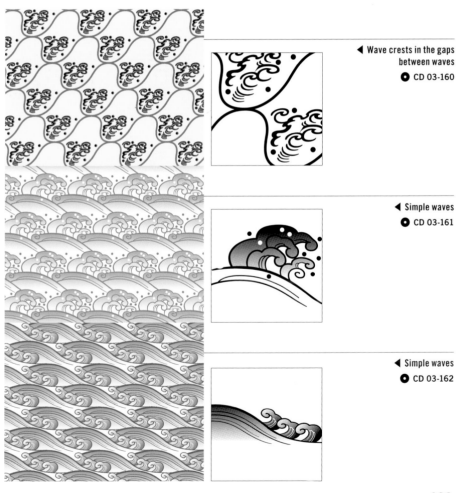

◀ Wave crests in the gaps between waves

🔘 CD 03-160

◀ Simple waves

🔘 CD 03-161

◀ Simple waves

🔘 CD 03-162

◀ Dark red sunset over ocean waves
● CD 03-163

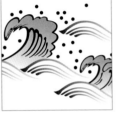

◀ Elegant waves - 1
● CD 03-164

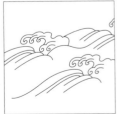

▶ Elegant waves - 2
● CD 03-165

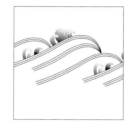

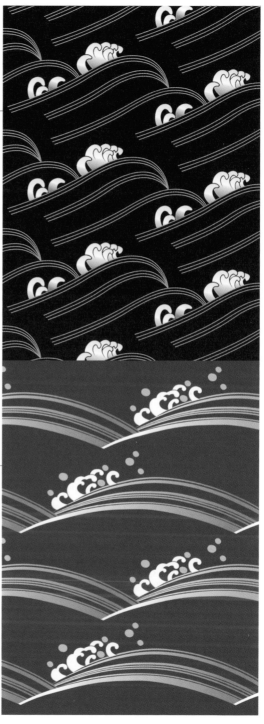

▶ Vast expanse of open sea - 1
● CD 03-166

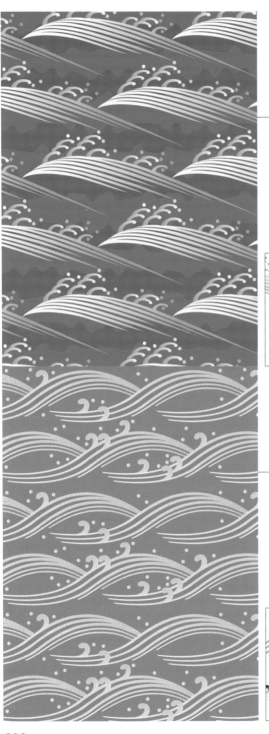

◀ Vast expanse of open sea - 2
● CD 03-167

◀ Aesthetic waves
● CD 03-168

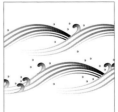

▶ Turbulent waves

● CD 03-169

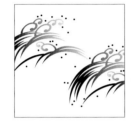

▶ Heavy seas
● CD 03-170

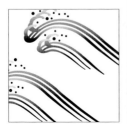

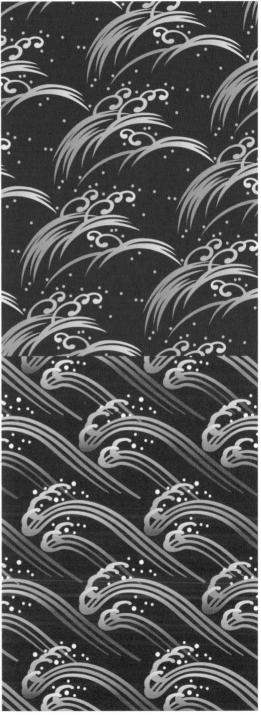

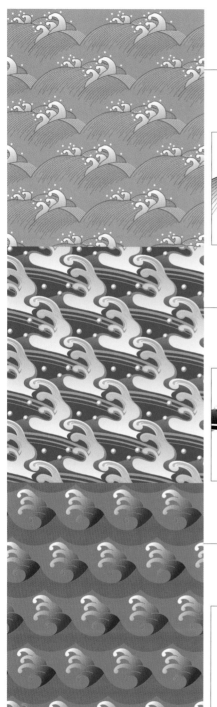

◀ Rugged waves
○ CD 03-171

◀ Spring waves
○ CD 03-172

◀ Designed waves
○ CD 03-173

▶ Sparkling waves
● CD 03-174

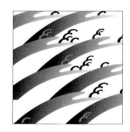

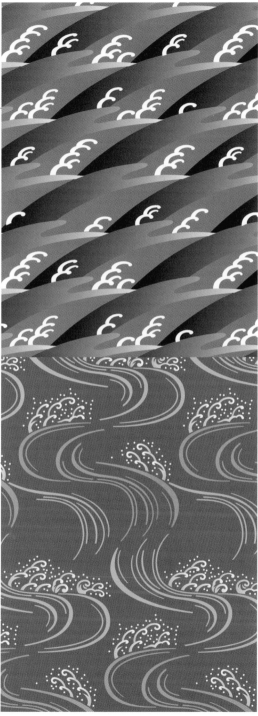

▶ Leaping rapids
● CD 03-175

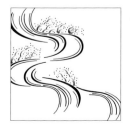

Woven Wave Patterns (*aya*) and Undulation

Even simple lines can be turned into attractive waves by selecting rippling waves, displaying them in a continuous pattern and adding color. Rippling waves are called "woven waves" and the perception that they are fitting for woven fabric may reflect the sensibilities that Japanese possess. "The woven pattern of waves" is even introduced in the "Tales of *Genji*" and the sense of a mandarin duck creating a circular design is expressed in the woven pattern of the rippling waves.

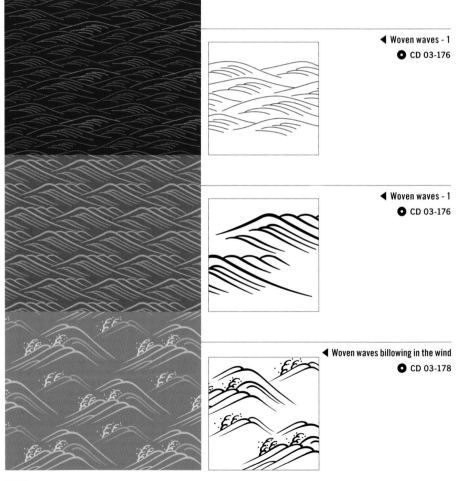

◀ Woven waves - 1
○ CD 03-176

◀ Woven waves - 1
○ CD 03-176

◀ Woven waves billowing in the wind
○ CD 03-178

▶ Woven waves rising with the rapids
● CD 03-179

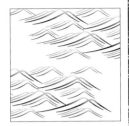

▶ Rolling waves shimmering in the light
● CD 03-180

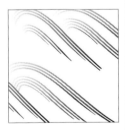

▶ Waves in a strong wind - 1
● CD 03-181

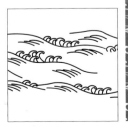

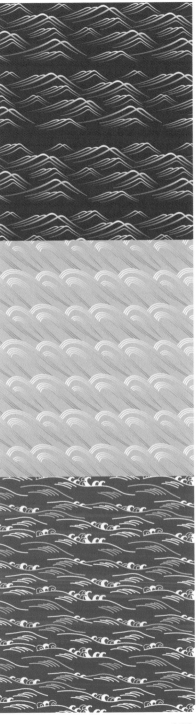

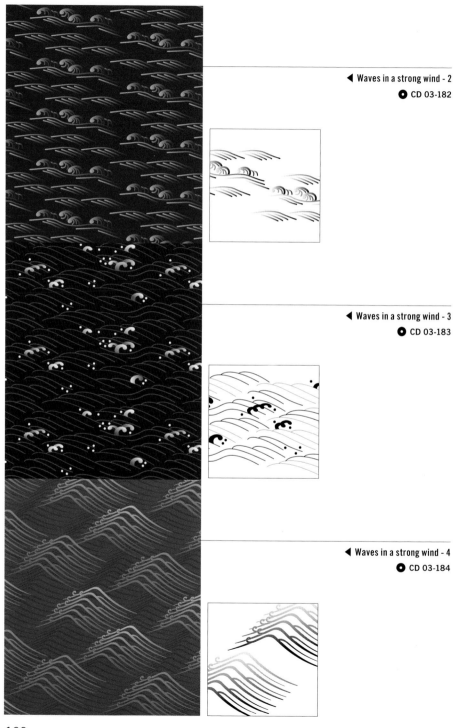

◀ Waves in a strong wind - 2
● CD 03-182

◀ Waves in a strong wind - 3
● CD 03-183

◀ Waves in a strong wind - 4
● CD 03-184

▶ A wave starting to undulate - 1
◉ CD 03-185

▶ A wave starting to undulate - 2
◉ CD 03-186

▶ A wave starting to undulate - 3
◉ CD 03-187

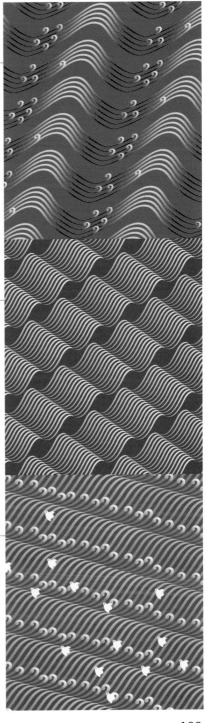

Development of Wave Designs

By arranging the crests of the traditional wave patterns in balanced geometric lines, wave designs can be achieved that consistently convey a sense of the era. There are limitations to the degree to which a design can be made abstract because design development concerns the design of the wave itself not just the "lines that form the shape of the wave." By adding wave crests or drops of water to the design a concrete representation of "the wave" is achieved and this should be the aim here.

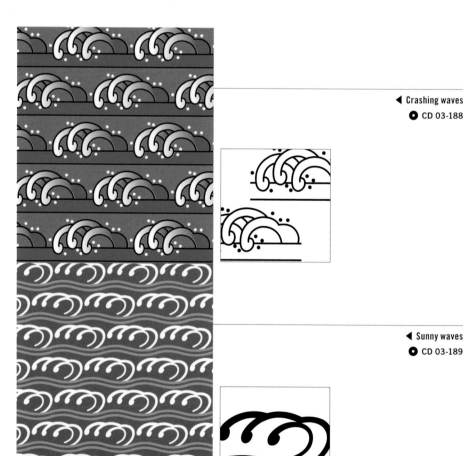

◀ Crashing waves
◉ CD 03-188

◀ Sunny waves
◉ CD 03-189

▶ Waves with a touch of pop-art - 1
◉ CD 03-190

▶ Waves with a touch of pop-art - 2
◉ CD 03-191

▶ Refreshing waves
◉ CD 03-192

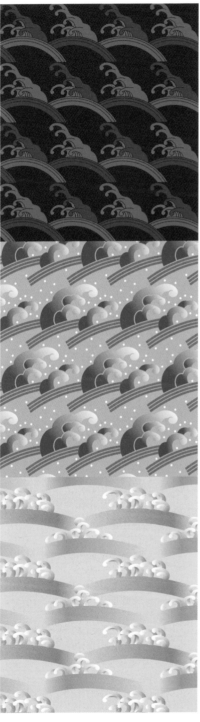

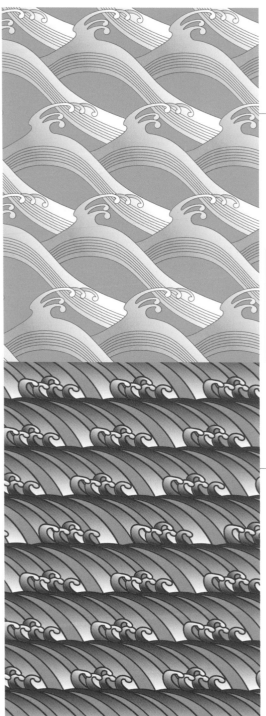

◀ Delicate waves
 ● CD 03-193

◀ Heavy waves - 1
 ● CD 03-194

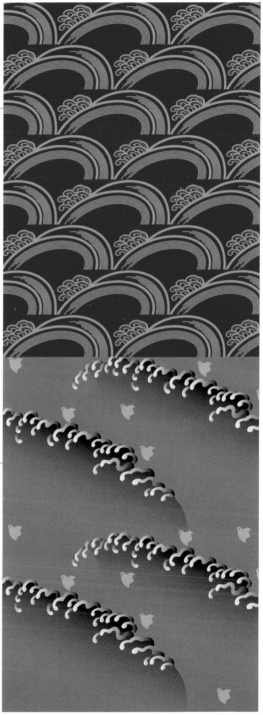

▶ Heavy waves - 2
○ CD 03-195

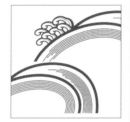

▶ Fantasy waves
○ CD 03-196

Symbolization of Waves

In order to show examples of how crest designs are made into woven patterns, it is fun to arrange the waves into kinds of symbols and create a continuous pattern. As the motif is waves, the crest designs do need to be connected in a wave-like flow but after the symbolization process it is no longer necessary to go through the phase of developing a continuous pattern. The concept behind symbolization in this case is "simplification of the perception of waves."

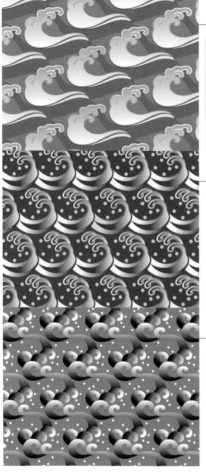

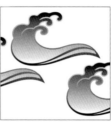

◀ Gaps between
the rolling waves - 1
● CD 03-197

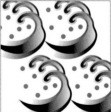

◀ Gaps between
the rolling waves - 2
● CD 03-198

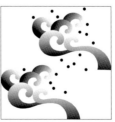

◀ Two kinds of wave
● CD 03-199

▶ Emphasis on continuous wave pattern
● CD 03-200

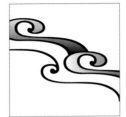

▶ Positive and negative wave symbols
● CD 03-201

▶ Curved lines of abstract waves
● CD 03-202

Dimensions of units

If wave patterns are repeated and arranged too neatly in a repeated way the effect may look a little out of place. It is considered better to arrange waves in an irregular way that can be adjusted according to the dimensions of various units. Also, it is possible to achieve a continuous pattern that looks natural and relaxed by composing a design from large units with continuous points on the top, bottom, left and right of the pattern.

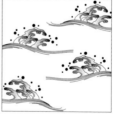

◀ Randomly placed waves - 1
● CD 03-203

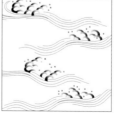

◀ Randomly placed waves - 2
● CD 03-204

▶ A woven wave pattern with multiple continuous points
⬤ CD 03-205

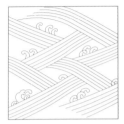

▶ Large rolling wave lines
⬤ CD 03-206

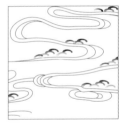

▶ Joining waves
⬤ CD 03-207

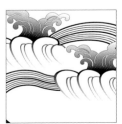

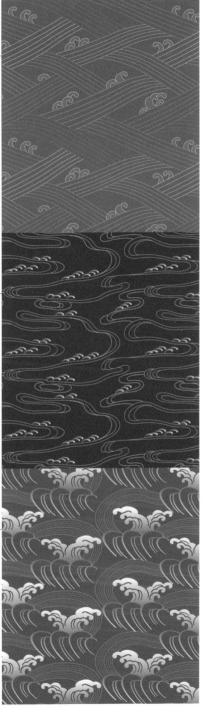

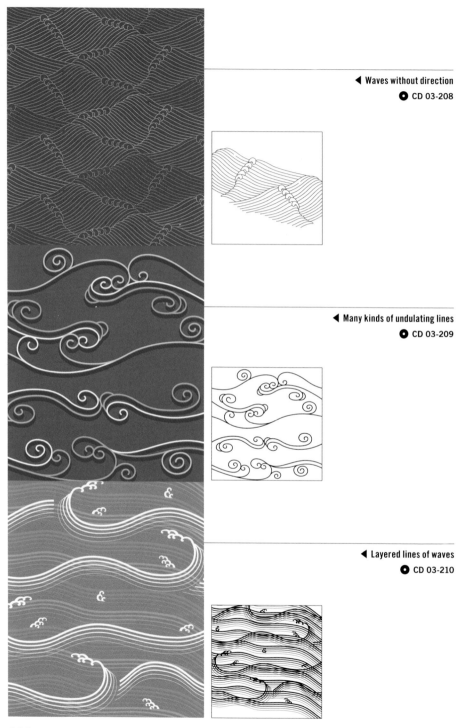

◀ Waves without direction
○ CD 03-208

◀ Many kinds of undulating lines
○ CD 03-209

◀ Layered lines of waves
○ CD 03-210

Chapter 4
Continuous Cloud Patterns
CD 03:121-210

Continuous Cloud Shapes

Like the natural flow of "floating clouds and running water" it is not difficult for clouds that endlessly cover the skies to be developed into a continuous pattern. Select any single cloud shape from the traditional cloud patterns in chapter two and you can create unique continuous cloud designs by applying some skills to repeating the pattern. One point that you need to be careful about is not to make the design too realistic; these are "patterns" and this means conveying the image of clouds.

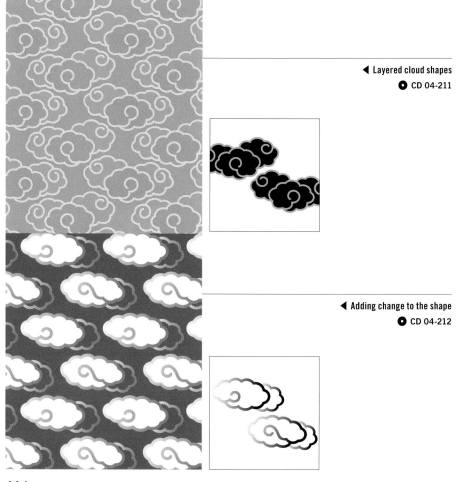

◀ Layered cloud shapes
◉ CD 04-211

◀ Adding change to the shape
◉ CD 04-212

▶ Units of randomly placed shapes
⬤ CD 04-213

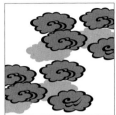

▶ Processing shapes
⬤ CD 04-214

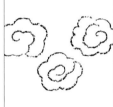

▶ Arranging the surface
⬤ CD 04-215

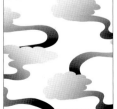

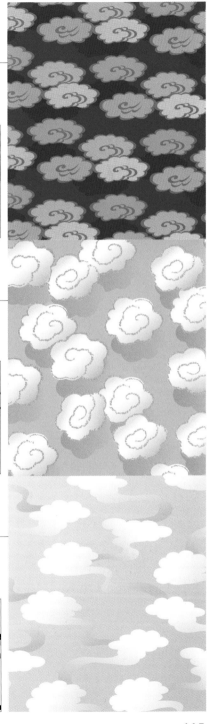

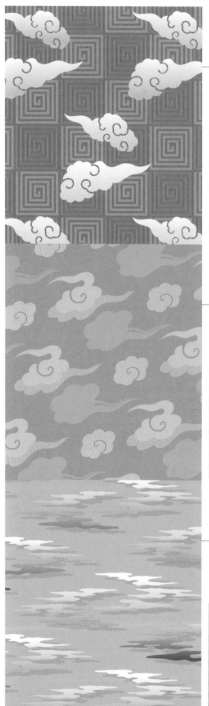

◀ Adding a background
● CD 04-216

◀ A unit of three kinds of clouds
● CD 04-217

◀ Blank spaces are consciously part of the picture
● CD 04-218

▶ Line clouds
● CD 04-219

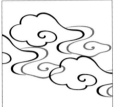

▶ Making curved lines from straight lines
● CD 04-220

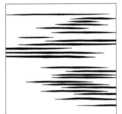

▶ Making a surface of lines
● CD 04-221

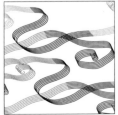

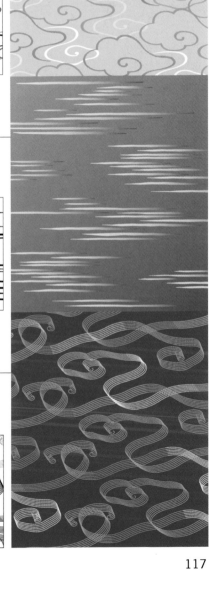

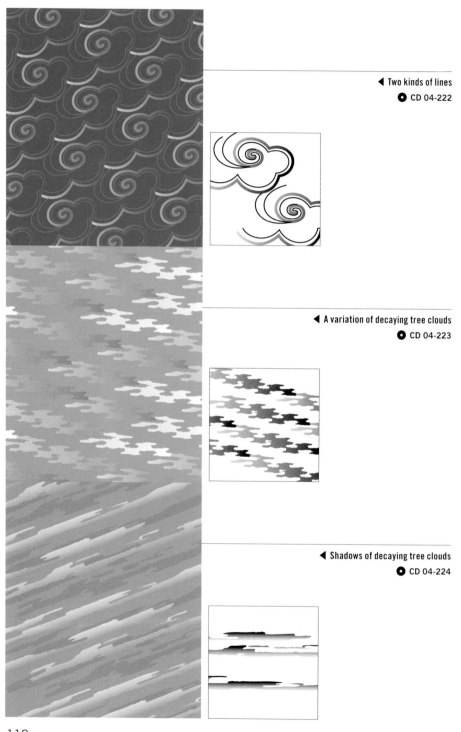

◀ Two kinds of lines
● CD 04-222

◀ A variation of decaying tree clouds
● CD 04-223

◀ Shadows of decaying tree clouds
● CD 04-224

▶ Small units of エ-shaped clouds
○ CD 04-225

▶ Negative picture of clouds floating up
○ CD 04-226

▶ Mist connections covering the surface
○ CD 04-227

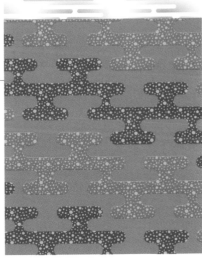

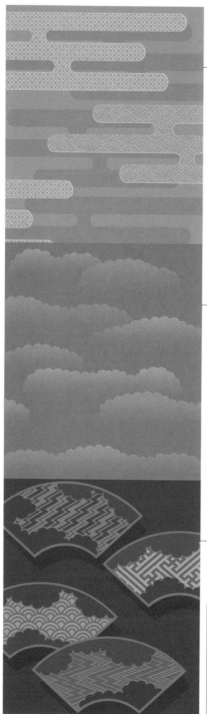

◀ Small designs in エ-shaped clouds
● CD 04-228

◀ The limit to reality in *Genji* clouds
● CD 04-229

◀ Indirect *Genji* clouds
● CD 04-230

▶ Decoration on *Genji* clouds - 1

◉ CD 04-231

▶ Decoration on *Genji* clouds - 2

◉ CD 04-232

▶ Creating new clouds from bow-shaped clouds - 1

◉ CD 04-233

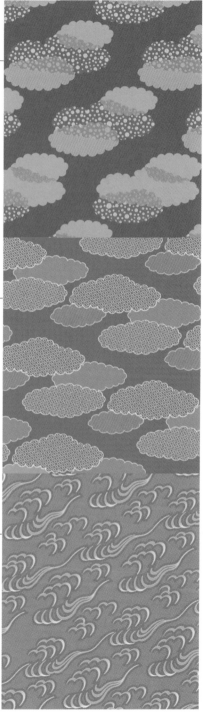

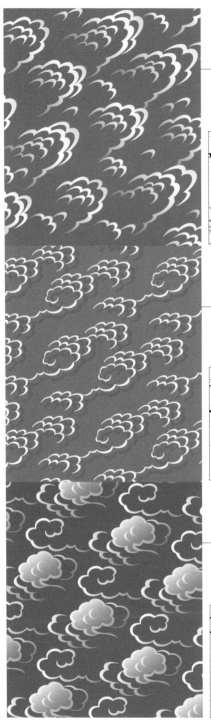

◀ Creating new clouds from bow-shaped clouds - 2
● CD 04-234

◀ Creating new clouds from bow-shaped clouds - 3
● CD 04-235

◀ Creating new clouds from bow-shaped clouds - 4
● CD 04-236

▶ Creating new clouds from bow-shaped clouds - 5
● CD 04-237

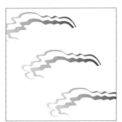

▶ Creating new clouds from bow-shaped clouds - 6
● CD 04-238

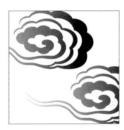

▶ Creating new clouds from bow-shaped clouds - 7
● CD 04-239

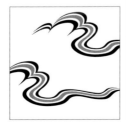

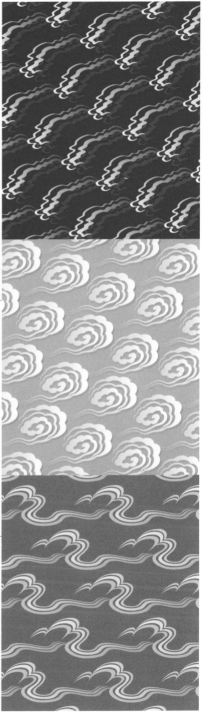

◀ Simple lineup of auspicious clouds
○ CD 04-240

◀ Random placement of auspicious lines
○ CD 04-241

◀ Big and small auspicious clouds
○ CD 04-242

► Auspicious clouds joined in a row
○ CD 04-243

► Mysterious auspicious clouds
○ CD 04-244

► Ethnic auspicious clouds
○ CD 04-245

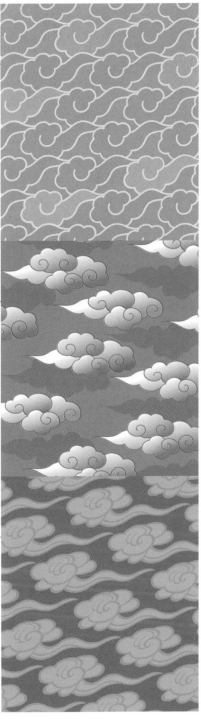

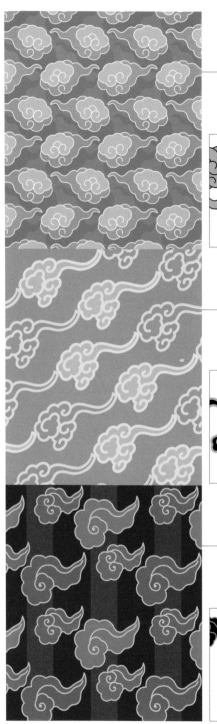

◀ Charming auspicious clouds
○ CD 04-246

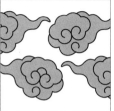

◀ Chinese-style auspicious clouds
○ CD 04-247

◀ Buddhist-style auspicious clouds
○ CD 04-248

▶ Clouds with a sense of profundity
● CD 04-249

▶ Dignified auspicious clouds
● CD 04-250

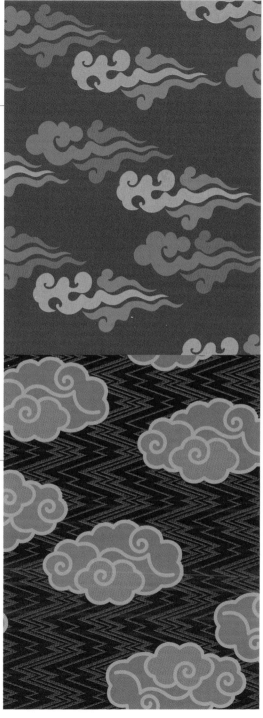

The Attached CD-ROM: Using the Material Provided

The purchaser of this book is permitted unrestricted use of the data recorded on the accompanying CD-ROM, either in its original form or in a modified fashion.

Credit or other such acknowledgment need not be noted in the event of such use. The data provided may also be used overseas, as use is not regionally restricted. Furthermore, copyright fees or secondary user fees are not required to use this material.

Adobe and Adobe Photoshop are either registered trademarks or trademarks of Adobe Systems, Incorporated registered in the United States and/or other countries. Microsoft, Windows, and Windows

XP are either registered trademarks or trademarks of Microsoft Corporation registered in the United States and other countries. Apple, Macintosh, Mac and Mac OS are either registered trademarks or trademarks of Apple Computer, Inc., registered in the United States and other countries.

All other brand and product names and registered and unregistered trademarks are the property of their respective owners.

About the Author

Shigeki Nakamura An art director since 1964, he established Cobble Collaboration Co. Ltd. in 1987. The company published a book of ESP Pattern Library Digital Materials, which can be seen on its website (cobbleart.com). He has received many awards, such as the Minister of International Trade and Industry Award, and he is a member of the JAGDA (Japanese Graphic Designer Association).